IMAGES
*of America*

# ANGEL FLIGHT
# MID-ATLANTIC

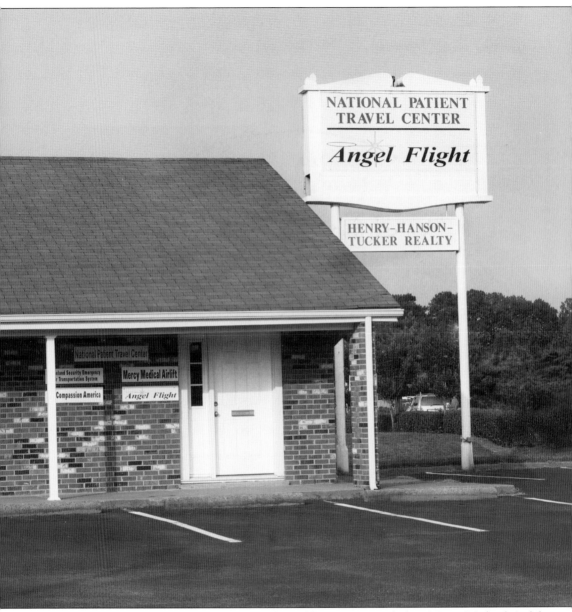

Angel Flight, together with several other charitable programs including Mercy Medical Airlift and the National Patient Travel Center, provides free medical air transportation for thousands of patients each year, operating from this modest brick building of office suites in Virginia Beach. The nonprofit groups are able to keep administrative costs down by working together, but the need for program funds is ongoing. (Robert Holman.)

ON THE COVER: The workhorse Bonanza has served Angel Flight faithfully since 1977, when it was bought by four pilots for charitable purposes. At the controls in this 1992 photograph is Dan Radtke, the command pilot for both the Bonanza and a Cessna 421 that was purchased for air ambulance service in 1985. The image was taken over the hills of the Blue Ridge Mountains near Culpepper, Virginia. (Paul Bowen.)

IMAGES
*of America*

# ANGEL FLIGHT
# MID-ATLANTIC

Suzanne Rhodes

ARCADIA
PUBLISHING

Published by Arcadia Publishing
Charleston SC, Chicago IL, Portsmouth NH, San Francisco CA

Printed in the United States of America

Library of Congress Catalog Card Number: 2007928860

For all general information contact Arcadia Publishing at:
Telephone 843-853-2070
Fax 843-853-0044
E-mail sales@arcadiapublishing.com
For customer service and orders:
Toll-Free 1-888-313-2665

Visit us on the Internet at www.arcadiapublishing.com

To Wayne, the love of my life.

# CONTENTS

# ACKNOWLEDGMENTS

I want to thank the many individuals and organizations that made this book possible, beginning with my visionary friend and boss, Ed Boyer, for saying "yes," for granting me time away from other duties, and for letting me pick his brain for nuggets of information known only by the founder of a great endeavor. The whole Angel Flight family has been most supportive, and I appreciate each of my coworkers for that.

I wish to thank my husband, Wayne, who accompanied me on several fact-finding missions and whose well-ordered mind and expertise as a pilot contributed to the project. Next, thanks go to Arcadia Publishing editors Courtney Hutton, Jami Sheppard, and Lauren Bobier; all helped navigate me through the book's details, both large and fine, and encouraged me along the way.

I am greatly indebted to Lou Sabatini for the excellent information found in his unpublished history of Mercy Medical Airlift. Others contributing information, photographs, hospitality, and other forms of assistance are Pete and Alice Buck, Carol Boyer, Steve Patterson, MaryJane Sablan, Clara Benjamin, Marion Myers, Katie Smith, Dr. Harry Beaver, Chuck VanNostrand, Louis and Barbara Ferreira, Cynthia and Brent Vukmer, Dr. James S. Nanney, Kathy Skipper, Gerardo Massey, Lesa Gilbert, J. Theodore Anderson, the staff at the National Archives in College Park, Maryland, Kate Igoe, Bill Sherrod, Brett Stolle, Tom Smoak, and the numerous patients, pilots, and staff members, past and present, who assisted me.

Finally, I wish to thank the Lord for opening many doors and for allowing me the pleasure of writing about Angel Flight and its origins.

An apology is in order regarding the hundreds of worthy pilots, patients, and staff who are not included in this book. How I wish I could display their faces and tell their stories too, but space and time made that impossible.

Readers, please note that when presenting the stories of our patients, I am following our organizational policy of omitting last names.

# INTRODUCTION

All great inventions have humanitarian as well as commercial potential, and so it is with the airplane. Only seven years after the historic Wright brothers' flight at Kill Devil Hill, North Carolina, two medical officers designed an airplane to transport the wounded. Capt. George H. R. Gosman and Lt. A. L. Rhoades of the U.S. Army built the first air ambulance in 1910. Although the airplane crashed on the test flight, the desire of aviators to help patients overcome obstacles of time and distance in the quest for medical care was destined to succeed.

In 1918, a Curtiss JN-4D "Jenny" biplane was converted into an air ambulance. Maj. Nelson E. Driver and Capt. William C. Ocker altered the rear cockpit to fit a standard army stretcher with one patient. The successful modification was standardized, and all military airfields were directed to maintain an air ambulance. More improvements followed in planes like the de Havilland, the Curtiss Eagle, and others.

A military surgeon wrote in 1921, "No longer will the luckless recruit . . . be jolted for hours in a rough riding automobile over cactus and mesquite, but borne on silvery wings . . . to the rest and comfort of a modern hospital."

From those early times, aeromedical operations, both military and civilian, have retained a proud history of service to the most vulnerable members of society—the sick and the injured.

Fast forward to 1972, when engineer Edward "Ed" R. Boyer and minister Dr. Louis Evans met for lunch at the stately Cosmos Club in Washington, D.C. As private pilots, they wanted to explore ways to combine flying with charitable causes. They left their meeting excited about their common vision. Angel Flight, though yet unnamed, was born.

At first, using borrowed or rented aircraft, Boyer and Evans flew sporadic patient flights, but mostly they flew for nonprofit organizations, shuttling speakers to meetings and foreign dignitaries to various destinations within the United States. Over time, they realized they needed to purchase their own airplane. Two other pilots joined the partnership, and in 1977, a Beech Bonanza 36 six-seat aircraft was bought. For its charitable transportation activities, the group called itself Washington Aviation Ministry (WAM), with Boyer as the president. It continued operations for several years, including the occasional patient mission, but was primarily an air taxi for prominent religious and humanitarian figures.

Then, in January 1983, a plane crash in Colombia altered WAM's course. Missionary pilot Tom Smoak survived and was hospitalized in Bogotá with an undiagnosed fever. Seeking specialized medical care, Smoak bought airline tickets and flew to Miami with his wife, Betsy, a nurse.

On arrival, Smoak was met by pilots Boyer and Paul Watson, who had been asked to help. This was to be the Bonanza's first air ambulance mission. Like its predecessor the Jenny, the plane was outfitted with an army stretcher to accommodate Smoak as he traveled to Washington, D.C., with Betsy as the flight nurse aboard. From there, Smoak, who had been an air force lieutenant and pilot, went to Walter Reed Army Medical Center.

In April 1985, a dying woman's request was granted for a flight home to Asheville, North Carolina, from a hospital in Washington, D.C. The mission convinced WAM members that their destiny lay in medical air transport. Afterward, all efforts were devoted to developing the medical side of public benefit flying. In 1984, another airplane was leased, and WAM became incorporated. The organization continued to grow, adding new volunteer pilots and members. WAM announced that more than two million safe passenger-miles had been logged from 1977

to 1986. As writer John B. Bruce stated in a company newsletter, "a new niche" was being carved "in the realm of volunteerism."

To better reflect the niche, WAM changed its name in 1987 to Mercy Medical Airlift (MMA), with Boyer continuing to serve as president. The next major leap was to lease and eventually purchase a Cessna 421C as a good choice for air ambulance operations. MMA established its headquarters in Manassas, Virginia, close to the airport where the Bonanza and Cessna Twin were kept. In 1990, after much effort, MMA received a Federal Air Carrier Certificate. The Part 135 elevated MMA's professional status and standardized operating procedures, maintenance, training, and other aspects. Also in 1990, a stretcher system was installed in the Bonanza.

To gain support and recognition, Boyer launched significant fund-raising activities. He also developed the National Patient Travel Helpline (NPATH), a call-referral service matching patient requests with resources, and added more than 100 "Special Lift" and "Child Lift" operations for patients enrolled in clinical trials requiring air travel.

With increased requests for transportation, Boyer and other MMA officials believed further expansion of fixed-wing, air ambulance operations was necessary and inevitable. Spin-off organizations in Texas and California were formed. Because the volunteer crew of nurses had grown inadequate for keeping pace with the demand for flights, MMA contracted with a professional aeromedical company to staff air ambulance missions.

Within a few years, many board members realized that, despite the increase in patient flights and even with patients absorbing a percentage of expenses, air ambulance service was too costly. A budget of $974,000 for those services in 1993 grew to $2.4 million in 1995. With maintenance costs on the 421C soaring, the board admitted it was time to revisit the vision and regroup.

Downsizing meant selling the Cessna Twin, reducing staff, halting expansion in other states, and moving to Virginia Beach, where operational costs would be lower and the community, with its large enclave of federal employees, more supportive.

In 1996, Boyer and his wife, Carol, bought a home in Virginia Beach and devoted a spare bedroom to MMA. (Manassas still maintained a satellite office with a part-time employee, as it does today.) The workhorse Bonanza was put to even greater service. As one of its original and continuing pilots, Lou Sabatini, put it, "The Bonanza had always been there, in the background, steadily operating, to fill in whenever and wherever necessary to meet demands of MMA."

The name Angel Flight was used to describe the fast-growing number of patient missions flown by volunteer pilots in their airplanes for distances under 1,000 miles. Mercy Medical Airlift became the parent organization and administrator for Angel Flight Mid-Atlantic and all other programs. Moreover, MMA formed partnerships with commercial airline companies to donate tickets and frequent flyer miles for patients needing to travel more than 1,000 miles.

With redirection, the expanding organization moved out of Boyer's house and into an office complex. Mission coordinators were hired. All programs were designed to fulfill the mandate of ensuring that no needy patient would denied access to medical care for lack of long-distance air transportation.

In 2000, Boyer cofounded Angel Flight America to improve service by standardizing procedures and formalizing cooperation among the six Angel Flight regional groups (including Mid-Atlantic) that had formerly operated as independent charities. In 2007, the national organization changed its name to Air Charity Network to better reflect the diversity of its programs.

Boyer worked with the board to establish other programs as well. The Homeland Security Emergency Air Transportation System (HSEATS) was created through a federal grant to quickly mobilize Angel Flight planes and pilots during a national emergency or disaster. Just days after the grant period ended, Hurricane Katrina struck. Angel Flight flew more than 2,600 missions, making it second only to the U.S. military in aviation disaster response.

To meet the public need for affordable air ambulance service, Air Compassion America (ACAM) was incorporated in 2004. The free service utilizes mission coordinators to process requests for help and to arrange flights by taking bids from air ambulance companies, then offering families the lowest negotiated prices. With some 23 flights arranged each month by ACAM, compared

to the five or six previously flown in MMA aircraft, and with an average savings of 38 percent, it was obvious Boyer and his associates had discovered an ingenious way to do air ambulance.

Angel Flight remains the heart of all these programs. Something about pilots, airplanes, and patients—the mix of the romance of aviation with sacrifice, suffering, and healing—touches people and renews their faith in the spirit of giving.

From a corps of 465 Mid-Atlantic pilots volunteering in 2001 to one of more than 1,500 in 2007, and from nearly 900 missions flown in 2001 to more than 2,000 in 2007, Angel Flight's capacity to help the needy has soared. Growth was due in part to a merger in 2003 with the second oldest and largest charitable aviation organization in America, AirLifeLine, which added 320 Mid-Atlantic pilots.

Most pilots own their aircraft, although some rent. They pay all expenses, including fuel, maintenance, and landing fees, and are a diverse group of men and women ranging in age from 20 to 80. They include doctors, farmers, lawyers, business owners, ministers, professors, and retired military officers. Some are husband-and-wife teams. Many are retirees who find reward in pursuing the passion of flying while helping others. Some fly only a few missions each year; others fly several each month.

Most pilots say they fly to "give back" to the community. If weather turns inclement during a scheduled flight, they sometimes purchase airline tickets for patients and, in extreme circumstances, even drive them to their destinations. Some are on call 24/7 for transplant missions. And, as noted earlier, they heroically flew into the hurricane-stricken Gulf region, transporting relief workers and supplies and evacuating hundreds of people to join their displaced families. These compelling Angel Flight stories were featured on all the major news networks.

Airplanes range from single-engine, four-seat models to high-performance turboprops—from the Mooney, to the low and slow Cessna 172, to the roomier, faster Beech Bonanza, to the twin-turboprop pressurized King Air. A few pilots even fly helicopters.

In the organization's complicated history, the one constant besides the pilots is the patients. From the beginning, it has always been about the patient—the name, the face, the smile, the tears, the crooked walk, the scarred body, the diminishing sight. Roughly 38 percent are children; 11 percent are veterans. They are infants, children, teenagers, mothers, fathers, service members, and the elderly. They suffer from a wide spectrum of illnesses from rare disorders like brittle bone disease and retinitis pigmentosa, to cancer of every type, to burns, to epilepsy, to hepatitis.

Families facing a health crisis can easily become medically impoverished. For them, the pilots are truly angels, providing free flights and relief from burdens. In their words: "Angel Flight pilots saved my life." "I cannot express to you how grateful I was not to have to make that car trip." "You gave us hope when we thought there was none."

There is sky enough for everyone in need to be "borne on silvery wings" of Angel Flight.

Photograph Legend:

USAF: United States Air Force
AF: Angel Flight
NASA: National Aeronautics and Space Administration
UFGCRC: University of Florida General Clinical Research Center
NBC: National Broadcasting Company
VJGC: Victory Junction Gang Camp
ESVT: Eastern Shore of Virginia Tourism
All other photographs are individually credited.

# One

# A HERITAGE OF HEALING

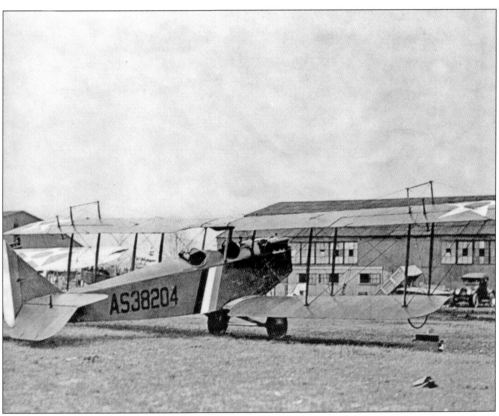

World War I was the arena for the first patient transport planes, but they lacked space for stretchers, and the open cockpits endangered the wounded. Efforts continued after the war to find a suitable plane for stretcher patients. The Curtiss JN-4, shown at the Langley Air Force Base in this 1920 photograph, was selected. One of history's most popular airplanes, the "Jenny" had been used as a military trainer. (National Archives.)

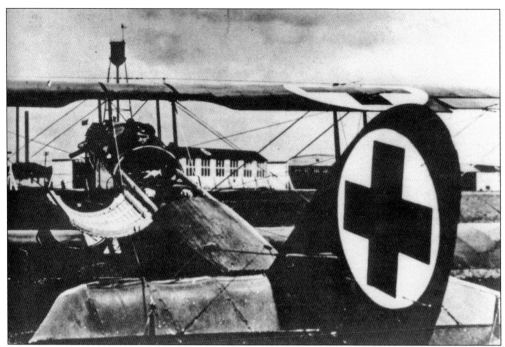

The Curtiss JN-4 was converted into an air ambulance in 1918 by Maj. Nelson E. Driver and Col. William C. Ocker of the U.S. Army at Gerstner Field, Louisiana. These early photographs, taken at Scott Field, Illinois, show the adaptation of the rear cockpit to accommodate a stretcher to carry the sick and the wounded, particularly pilots involved in crashes. The modified Jenny air ambulance, intended primarily to be a crash-rescue plane, flew at a top speed of 128 kilometers per hour and was to be stationed at all flying fields. (USAF History and Museums Program.)

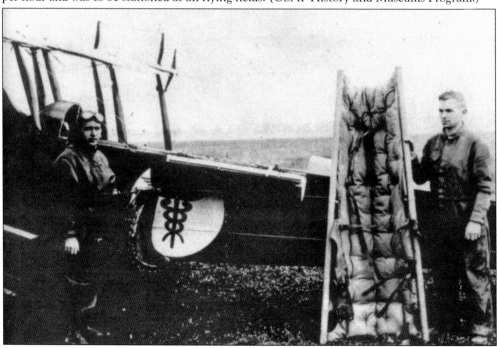

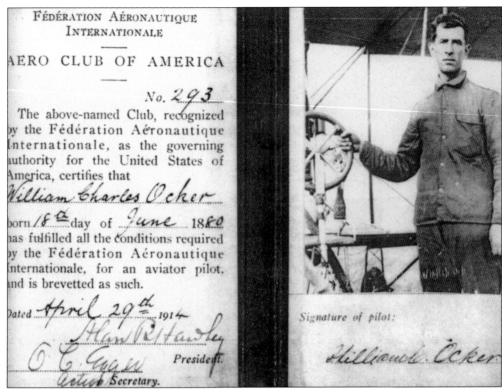

FÉDÉRATION AÉRONAUTIQUE
INTERNATIONALE

AERO CLUB OF AMERICA

No. 293

The above-named Club, recognized by the Fédération Aéronautique Internationale, as the governing authority for the United States of America, certifies that

William Charles Ocker

born 18th day of June 1880 has fulfilled all the conditions required by the Fédération Aéronautique Internationale, for an aviator pilot, and is brevetted as such.

Dated April 29th 1914

Alan R Hawley President.

O. C. Eggen Acting Secretary.

Signature of pilot:

William C. Ocker

William C. Ocker, born in Philadelphia in 1876, is known as the "Father of Instrument Flight" for his innovations in aviation safety through instruments. Though his contribution to the design of the first air ambulance may not be as widely known, it is nevertheless a milestone achievement. The photograph of his aviator's license is from 1914. (Lee Arbon Collection, National Museum of the USAF.)

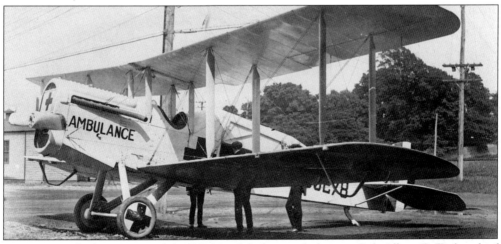

Recognizing the limitations of the JN-4 modified air ambulances, Col. Albert E. Truby, chief surgeon of the U.S. Army Air Service, asked the air service's engineering division to design an airplane to allow for a pilot, a medical attendant, and two patients. The airplane was the de Havilland DH-4. This photograph was taken in 1920 at the Anacostia Naval Air Station. (National Archives.)

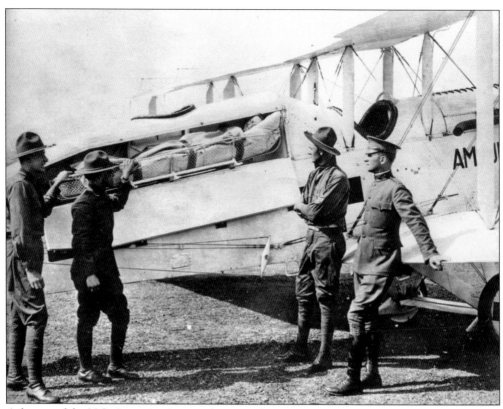

A fixture of the U.S. Army Air Service during and after World War I, the DH-4 was converted so as to accommodate two patients placed side by side in the fuselage. The basket litter, commonly called the Stokes litter after Charles Stokes's 1895 design, was constructed with a tubular metal frame and chicken wire for forming the basket. This photograph was taken c. 1919. (USAF.)

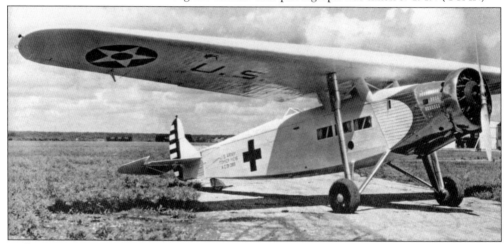

Budget constraints delayed the air corps' plans to buy aircraft made expressly for aeromedical evacuation and recovery missions, so the army used existing aircraft—the Fokker Y1C-14 and C-15. The C-15, photographed here in 1931, was a cargo airplane modified to hold four stretcher patients and two medical officers, but it was too large and heavy for emergency operations enacted on small fields. (Smithsonian Institution.)

# Two

# Four Men and an Airplane

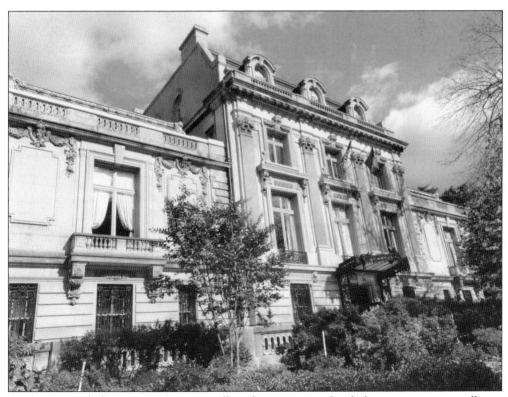

Civilian air ambulance operations, as well as the transport of ambulatory patients, are all part of Angel Flight's history. It all started here at the Cosmos Club in Washington, D.C., where Ed Boyer and Dr. Louis Evans conceived the idea to organize charitable flying. In 1972, the two men, both pilots, had lunch in the splendid Townsend Mansion, described by a Cosmos Club historian as "one of the jewels of Embassy Row." (Gerardo Massa.)

Ed Boyer and Dr. Louis Evans, eager to use their flying skills to help others, were guests of a friend with a membership in the elite club. The setting could not have been more appropriate. Founded in 1878 by John Wesley Powell as a center of intellectual exchange and social fellowship, the Cosmos Club has counted among its members 3 U.S. presidents, 2 vice presidents, 12 Supreme Court justices, 32 Nobel Prize winners, 56 Pulitzer Prize winners, and 45 recipients of the Presidential Medal of Freedom. The Townsend Mansion was built around 1900 by noted architects John Merven Carrère and Thomas Hastings. The ornate stone exterior reflects the style of Louis XVI. The interior also evokes lavish French period styling. The building is listed individually on the National Register of Historic Places and is designated as a District of Columbia Landmark. (Gerardo Massa.)

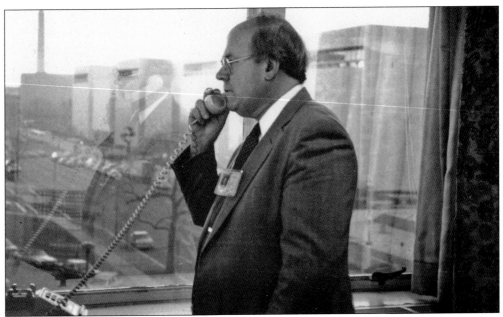

Ed Boyer, photographed in 1984 in his office in Washington, D.C., at the Department of Health and Human Services, spent 29 years as a federal engineer. But his greatest mark is his effort of more than 30 years to develop a comprehensive charitable medical air transportation system in the United States. He started small, using rented or borrowed aircraft to fly for humanitarian causes. (Shirley Engen.)

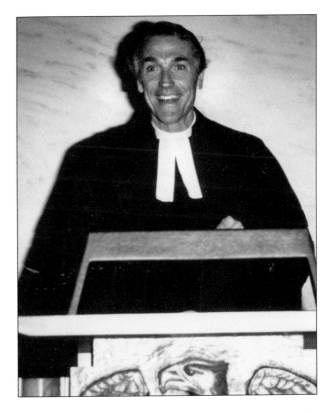

*Time* magazine described Dr. Louis Evans, shown here in 1984, as "one of the most successful clergymen in the U.S. . . . a big, brisk man" and a "compelling preacher" with "contagious enthusiasm" and "organizing ability." He was senior pastor of National Presbyterian Church in Washington, D.C., where Ed Boyer was a member. For public benefit flights, the two men borrowed a parishioner's Bonanza and other planes for about five years. (Shirley Engen.)

Realizing they needed their own plane and finding the Bonanza most suitable, Ed Boyer and Dr. Louis Evans brought in a partner, Maj. William Buckingham, an air force officer with a doctorate in political science. Buckingham flew to New York in 1977 to check out a prospective airplane, a Bonanza A36. After having it inspected, the men purchased the airplane and took it to the Leesburg airport in Northern Virginia. (Shirley Engen.)

Another partner was sought, and Brig. Gen. Paul Watson, a retired air force officer, joined the group of Bonanza owners. Watson enjoyed a distinguished military career and ended his flying tenure with the U.S. Air Force as an F-4 wing commander in Vietnam. It was in Vietnam that Ed Boyer, on assignment for the government, had met Watson. (Shirley Engen.)

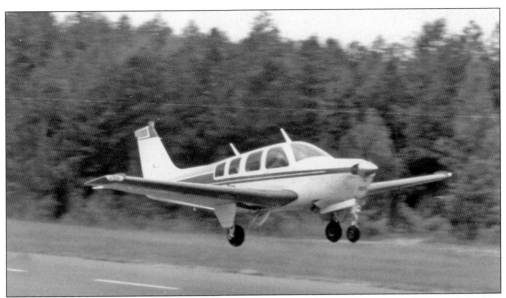

The six-seat Bonanza N7709R, which logged approximately 200,000 passenger miles its first year, is shown in this 1979 photograph taken in Waxhaw, North Carolina. The avionics package, photographed in 1980, is slightly modified from the original. The 36 Beechcraft Bonanza was introduced in 1968 as a high-performance, heavy, single-engine aircraft. Along with the Douglas DC-3, the Bonanza earned *Fortune* magazine's award in 1959 as one of the 100 best designed mass-produced products. N7709R was used primarily to shuttle religious and humanitarian leaders to speaking engagements, conferences, and other events, although patients were also sporadically transported. To formalize the service, the name Washington Aviation Ministry (WAM) was chosen. (MMA.)

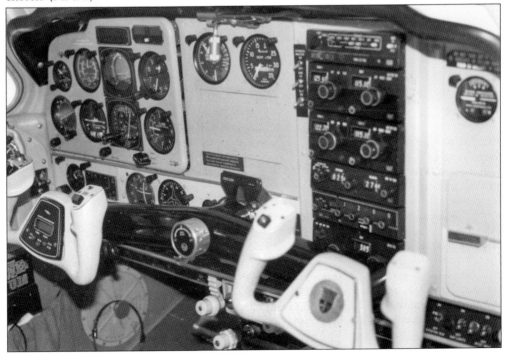

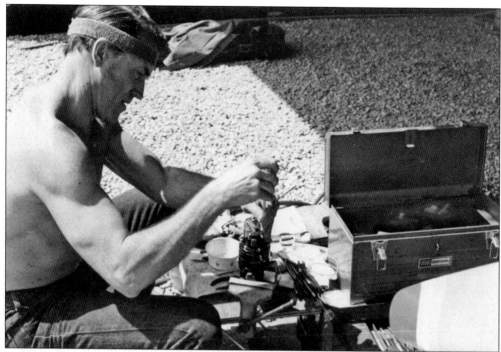

Dr. Louis Evans was a highly skilled mechanic and maintenance chief for the Bonanza. As a teenager he had worked on the B-17 bomber (World War II) assembly line. One of the four original Bonanza pilots and owners, Evans had learned to fly in San Diego, California, while serving as pastor of the La Jolla Presbyterian Church. Evans, shown making an adjustment in this 1980 picture, was a fully qualified commercial, single- and multi-engine, instrument-rated pilot. Maintenance of the Bonanza was exceptional. An extensive annual inspection as required by the FAA was given twice a year. Minor maintenance and routine inspections were performed each month. The 1984 photograph of Evans with Ed Boyer (left) shows them working on the aircraft at Hagerstown (Maryland) Aircraft Services. (Above, Coke Evans; below, MMA.)

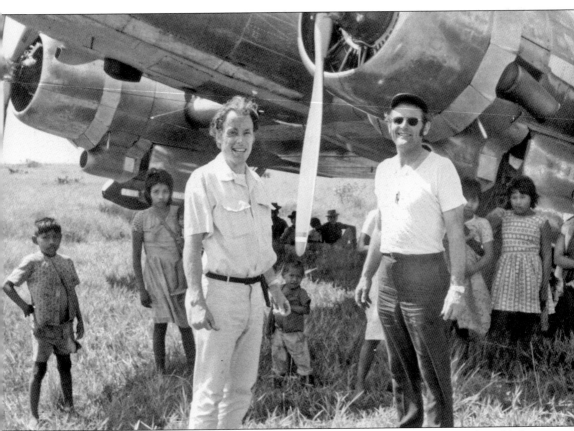

In 1983, a mishap in South America led to the first air ambulance flight and helped establish the ministry's distinct medical orientation. Tom Smoak, a missionary pilot with Jungle Aviation and Radio Service (JAARS), went down in an airplane crash in a remote area of Colombia. He survived and was hospitalized in Bogotá, where he developed a mysterious and undiagnosed fever. Seeking specialized care, Smoak and his wife Betsy, a nurse, bought airline tickets and flew to Miami, where Ed Boyer and Paul Watson were waiting with the Bonanza. Boyer served on the JAARS board and had been contacted to assist the ailing man. With Smoak on an army stretcher fitted into the airplane and Betsy on board, the men flew to Washington, D.C. Smoak, a former air force pilot, was treated at Walter Reed Army Hospital. In this 1973 photograph, Smoak is shown (left) with another JAARS pilot, Roy Minor, and native Colombians. The airplane is a DC-2. (Tom Smoak.)

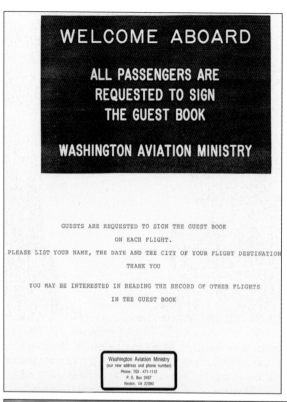

WELCOME ABOARD

ALL PASSENGERS ARE
REQUESTED TO SIGN
THE GUEST BOOK

WASHINGTON AVIATION MINISTRY

GUESTS ARE REQUESTED TO SIGN THE GUEST BOOK
ON EACH FLIGHT.
PLEASE LIST YOUR NAME, THE DATE AND THE CITY OF YOUR FLIGHT DESTINATION
THANK YOU

YOU MAY BE INTERESTED IN READING THE RECORD OF OTHER FLIGHTS
IN THE GUEST BOOK

Washington Aviation Ministry
(our new address and phone number)
Phone: 703 - 471-1112
P. O. Box 2457
Reston, VA 22090

With increased calls for medical flights and more pilots volunteering, Washington Aviation Ministry (WAM) incorporated in 1984. The next year, the nonprofit organization leased a Cessna 335 from an Oklahoma businessman. Passengers were made to feel welcome, as shown in this sign. Though the Cessna was non-pressurized and weight sensitive, it was, as pilot Lou Sabatini said, "a major step in the medical transport program." (Shirley Engen.)

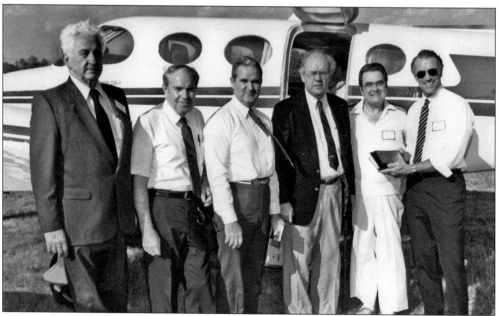

Because a charitable air ambulance operation is an undertaking of mighty proportions, it was appropriate that WAM's board hold a ceremony dedicating the Cessna Twin to the service of God and man. Board members in this photograph taken at Montgomery County Airpark, Maryland, on October 21, 1984, are (from left to right) Paul Watson, Charlie Ake, Tom Hopkins, Ed Boyer, Cliff Robinson, and Louis Evans. (Shirley Engen.)

Friends and supporters turned out for the WAM dedication led by Rev. Louis Evans. The charity flew in or out of several states, including Virginia, West Virginia, Maryland, Delaware, Washington, D.C., Pennsylvania, North Carolina, Tennessee, New Jersey, and New York City. In a *Richmond News Leader* article dated August 17, 1985, Ed Boyer stated, "We never really realized the need for medical transport . . . there's an enormous need." Patients contributed to the cost of the flight—in 1986 about $900 just for operating the plane—but nobody got turned down who could not pay. Newspapers carried stories of patients whose lives were saved or improved because of the unique air ambulance program: a terminally ill cancer patient wanting to go home, a patient needing a liver transplant, a premature infant requiring specialized care. (Shirley Engen.)

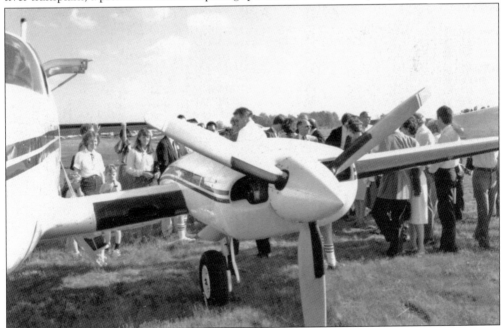

Not only did the number of pilots increase, but also the number of volunteer flight nurses. By 1988, there were 30 volunteer nurses and EMTs. But matching schedules with flights was always a challenge. Lauren Farley, a WAM support nurse, is shown in 1984 in the left photograph at the Cessna 335 dedication service. Another nurse, Ramona Currie, began volunteering in 1989 and is shown in the bottom picture, taken in 1983. She explained that "our patients were all basic life support. Most were at the losing end of a long illness. It wasn't as sad as it sounds. The patients and their loved ones were always glad to be reunited." (Left, Shirley Engen; below, Ramona Currie.)

Dr. Harry Beaver, a physician practicing in Northern Virginia and shown in the top picture, became chairman of the WAM Medical Committee in 1986. He continued serving for several years after the group became Mercy Medical Airlift. Joining him in oversight of medical operations was Dr. Ben Aaron, a private pilot and chief of cardiovascular and thoracic surgery at George Washington University in Washington, D.C. Aaron was famous for a critical moment in history: he removed the bullet that had lodged an inch from Pres. Ronald Reagan's heart following an assassination attempt in 1981. Aaron is pictured below at a press conference with Dr. Arthur Kobrine. (Above, Harry Beaver; below, George Washington University.)

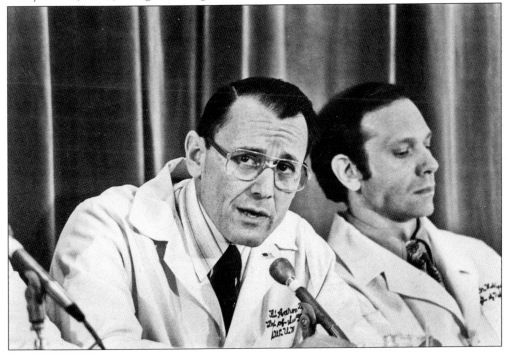

In May 1985, an airplane ran into the parked Cessna 335, disabling it. To fill the gap, Harvey Engen donated his Baron 58, as shown in this picture of an unidentified patient who traveled from Baltimore, Maryland, to Indianapolis, Indiana, reclining on an army stretcher. Engen, with his son Steve, logged 300 hours in the aircraft for WAM. Meanwhile, the Cessna 335 was repaired and returned to its owner. (Shirley Engen.)

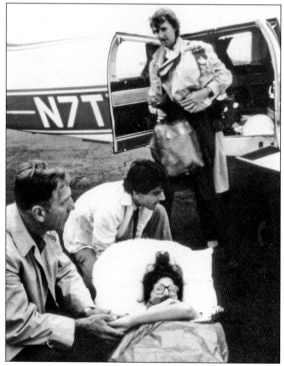

In June 1985, WAM transported the 19-year-old daughter of an Episcopal priest from Casper, Wyoming, to Teterboro airport in New Jersey following a serious automobile accident that left the girl paralyzed from the chest down. Jennifer flew with two pilots and a medical assistant in Engen's Baron. WAM paid all expenses, totaling about $1,600 in direct costs. (Joe Giardelli.)

# *Three*

# MERCY MEDICAL TAKES OFF

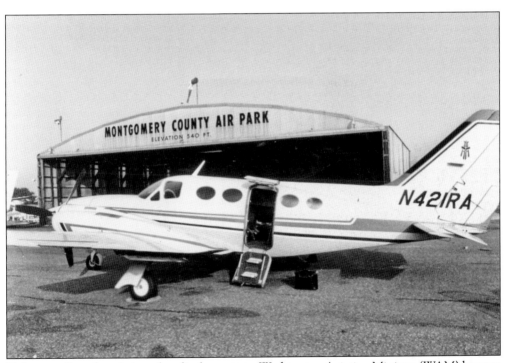

To better reflect the mission of medical transport, Washington Aviation Ministry (WAM) became Mercy Medical Airlift (MMA) in 1987. Two years prior, a Cessna 421C Twin had been leased as a suitable choice for air ambulance service. In 1988, the Cessna was purchased with funds largely donated by MMA's command pilots. The pressurized aircraft, shown in this 1985 photograph, had radar, de-icing equipment, and a fairly good payload. (MMA.)

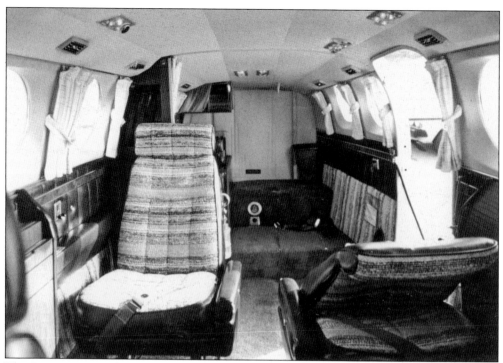

The Cessna 421C, with its turbocharged twin engines, was a popular executive transport airplane in the 1970s and 1980s. The interior depicted in this 1985 photograph was remodeled for air ambulance service, including the installation of a LifePort stretcher system and other equipment needed by a medical crew and modifications to provide electricity. MMA's logo, the medical cross, was displayed on the tail, as seen in this 1988 photograph, placing it historically in the lineage of aeromedical carriers such as the Curtiss JN-4 and the de Havilland DH-4, which dated back to the early part of the 20th century. (Above, MMA; below, Harry Beaver.)

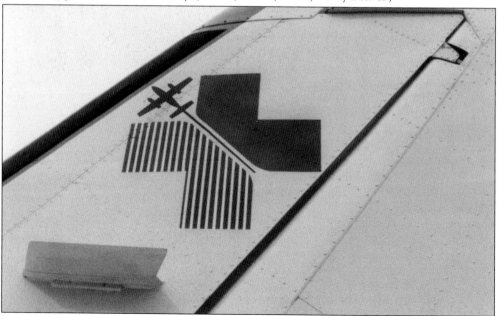

Mercy Medical Airlift moved to Manassas, Virginia, and acquired generous hangar space at a reduced rate at the airport's new east ramp. Both the Cessna 421 and the Bonanza were kept here, as seen in this 1988 picture. There were offices for maintenance and pilots, and a washing machine was available for flight nurses to use to launder sheets from the stretcher. (MMA.)

Besides being a pilot, Steve Engen, shown in this 1985 photograph, had been WAM's director of maintenance, working on airplanes in the large, unheated hangar in Gaithersburg, Maryland. After the name change and move to Manassas, Virginia, he continued to serve as director of maintenance and went on to earn his Inspector Mechanic status from the FAA. (Shirley Engen.)

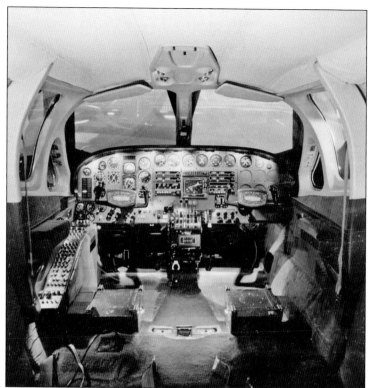

The flight simulator seen in this 1985 photograph was used for training pilots to serve as pilots in command of the Cessna 421. Simcom Systems, Inc., in Orlando, Florida, provided instruction at a large discount to the volunteer pilots. Training lasted for a period of five days. (Simcom Systems.)

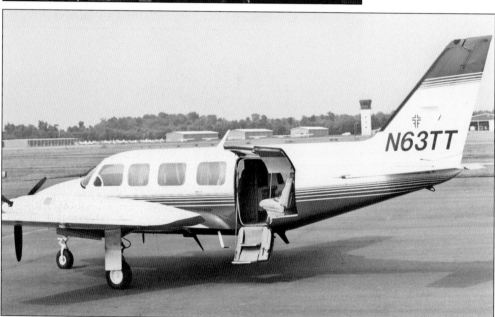

For a short time, MMA used this Piper Navajo airplane, which belonged to the directors of a Manassas bank who wanted to help the charity. But for each mission, the airplane had to be adjusted from a corporate setting to a medical one and back again, an impractical and time-consuming operation. Furthermore, the Navajo was non-pressurized and was often wanted by the bank just when MMA needed it. (Harry Beaver.)

One of the most distinguished pilots and a key leader in the developing organization was Maj. Gen. Click Smith. After his air force retirement, Smith joined WAM as a command pilot in 1984. Later he was named chief pilot, designated FAA check airman, and board chairman for Mercy Medical Airlift. Concerned with safety, pilot proficiency, and standard operating procedures, Smith made sure the volunteer organization operated professionally. (Shirley Engen.)

Click Smith, photographed in this F-4 Phantom in 1968, was a highly decorated military command pilot, flying for more than 30,000 hours in 68 types of aircraft. Smith served in Korea and Vietnam and earned a Purple Heart, the Air Force Distinguished Service Medal, and many other honors. MMA board member Bud Harper described the general as "a symbol of servant leadership" following his death in 2004. (Iris Smith.)

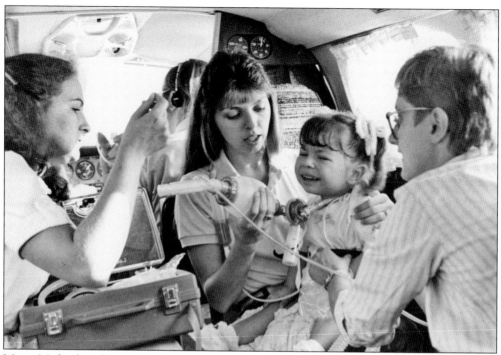

Mercy Medical Airlift provided transportation for this two-year-old girl and her parents. In these photographs, taken in 1986, the child is traveling in the Cessna 421 from her home in Charleston, West Virginia, to Pittsburgh, Pennsylvania, for surgery to correct a rare, congenital, restrictive thoracic disorder that left her unable to breathe, drink, or eat without the aid of medical technology. Ten percent of Americans suffer from a rare disorder and require specialized treatment, usually at distant medical facilities. This is why MMA's niche is so vital. In the top picture, the girl's mother and father are suctioning her while the nurse on board assists. In the bottom picture, the family and flight crew are disembarking. (Shirley Engen.)

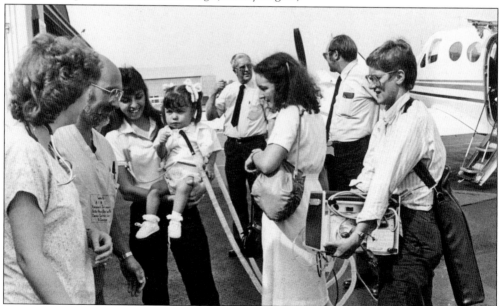

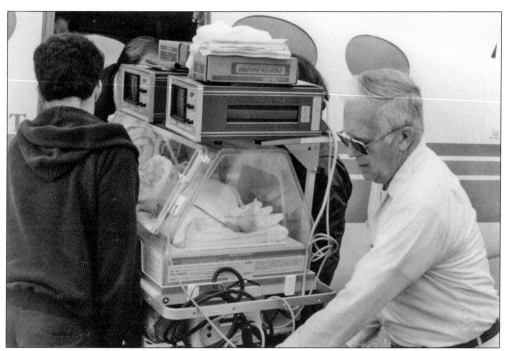

In April 1988, Mercy Medical Airlift flew two premature infants in the Cessna 421 from Washington, D.C., to Indianapolis, Indiana. The mother had been traveling and gave birth in the District of Columbia. Her insurance company would not cover the cost of the transport home. MMA was contacted and did not hesitate to take the mission. Baby Greg weighed only 4.5 pounds. Baby Tyler weighed 4.2 pounds. Pilot Harvey Engen is shown helping to load the incubator carrying the babies. The medical equipment seen here was loaned by George Washington University Hospital. The flight took two and a half hours. (Harry Beaver.)

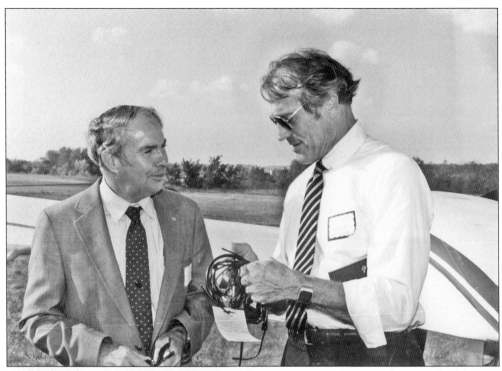

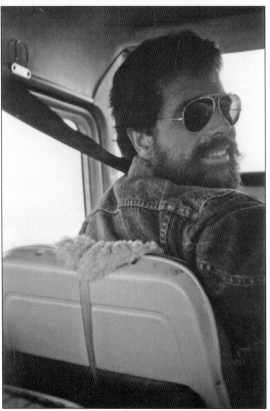

MMA's volunteer pilots were highly experienced, averaging 11,800 hours of commercial flying time. Charlie Ake was a board member and command pilot who had signed up with WAM and continued with MMA following 32 years as a pilot for United Airlines. In this 1984 picture, Dr. Louis Evans is handing Ake new headsets for use in the Cessna 335. Lou Sabatini also flew with WAM beginning in 1985 and still flies the Bonanza as a command pilot and MMA board member. Shown flying a rented Cessna 120 in this 1987 picture (left), Sabatini has been a pilot since 1977. He learned to fly in the Alaskan wilderness and earned pilot ratings for airline transport and for commercial single-engine sea and commercial gliders. He is also a certified flight instructor. (Above, Shirley Engen; left, Lou Sabatini.)

Ed Boyer earned his private pilot's license in 1961 and holds multiple ratings. His flying experience, a 29-year career in government, and his Christian faith prepared him well for his role in creating the system of charitable medical air transportation in America. A professional engineer and commissioned army officer, Boyer developed the flight test program of the Advanced Nike Hercules Air Defense System and served in Vietnam, managing the design and construction of U.S. air bases. He worked for the Department of Health and Human Services and was on executive loan from the government to develop the National Patient Travel Center. The right picture of Boyer flying an unidentified child patient and his mother was taken c. 1990. The photograph below, taken in 2000, shows the usually business-like Boyer (third from left) horsing around with the staff. (MMA)

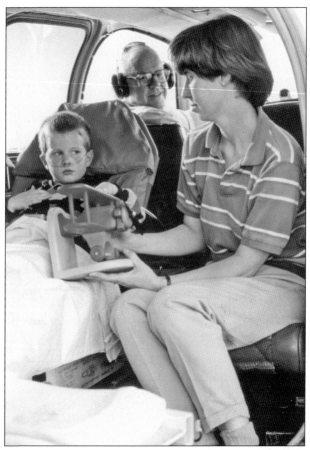

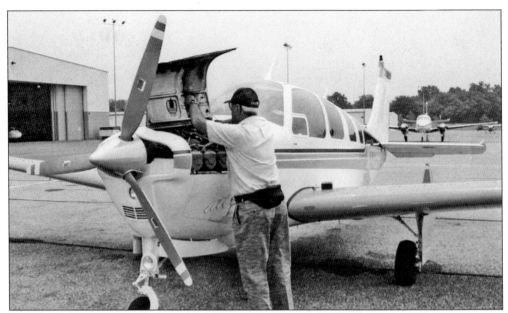

Bob McCamish's service with Mercy Medical Airlift is long and distinguished, beginning in 1994. A former air force officer and an electrical engineer, McCamish is a designated chief pilot, air transportation flight instructor, and FAA check airman for the organization. In the above photograph, taken in July 2002 at Tri-Cities Regional Airport in northeastern Tennessee, McCamish checks the engine oil level of the Bonanza in preparation for a patient flight. Another long-time Bonanza pilot and co-owner is Chuck VanNostrand. In the photograph below, taken in March 2007, VanNostrand (left) is shown with a patient, Carl, and Carl's wife, Lynn. On the far right is the connecting pilot, David Rose, who flew the couple from South Carolina to Richmond, Virginia. VanNostrand continued the trip to Philadelphia, where Carl was treated at Drexel University Hospital. (Above, Harley Sheffield; below, Chuck VanNostrand.)

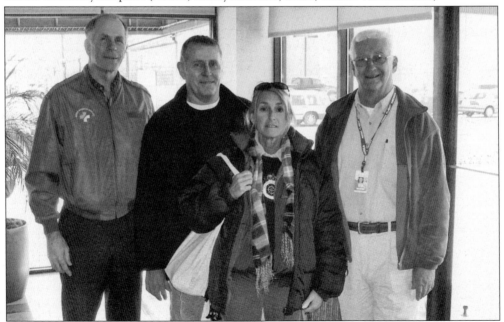

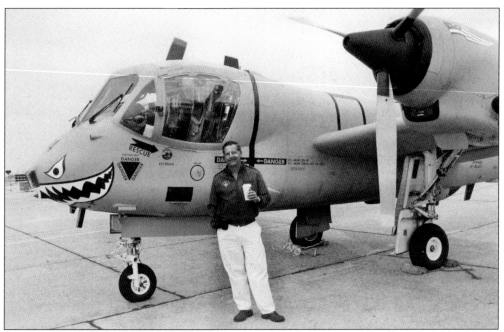

A pilot in command for the Bonanza and an Angel Flight pilot, Jeff Douglass has flown 5,300 hours and holds 10 pilot ratings. In the top picture, Douglass is standing in front of a Grumman OV-1D Mohawk tactical aircraft at the Langley Air Force Base air show in April 2007—definitely not an Angel Flight plane! His day job is in information technology, where he sells network engineering services for a small firm. In the photograph below, Douglass had picked up a stretcher patient in Greenwood, South Carolina, and flown her to the Teterboro airport near New York City where she would undergo treatment. (Jeff Douglass.)

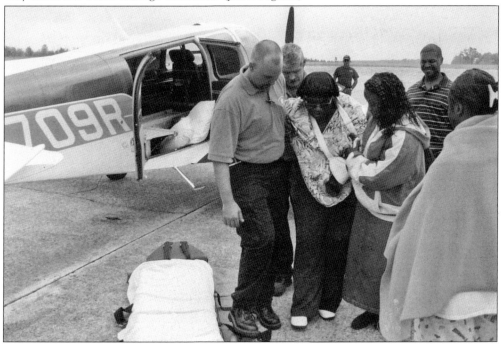

Rick Moss got his private pilot's license in 1989 and bought a Cessna 172XP. He earned multiple ratings and joined Mercy Medical Airlift in 1994 and Angel Flight in 1996. When not flying or enjoying his other hobby, the violin, as shown in this 2000 picture, Moss works for the federal Broadcasting Board of Governors. Dan Radtke's service to his country includes flying 307 combat missions in F-4s, which earned him 23 air medals and three Distinguished Flying Crosses. A former flight engineer and pilot for Eastern Airlines, Radtke joined MMA in 1990 and was a pilot in command for the Cessna 421, as shown in this photograph. The plane was named *Natasha* for a short time to honor a deceased patient. Radtke, a real estate broker in Northern Virginia, flew the Bonanza too, logging 350 hours. (Above, Rick Moss; below, Dan Radtke.)

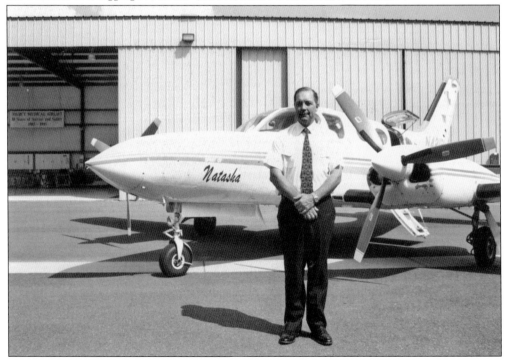

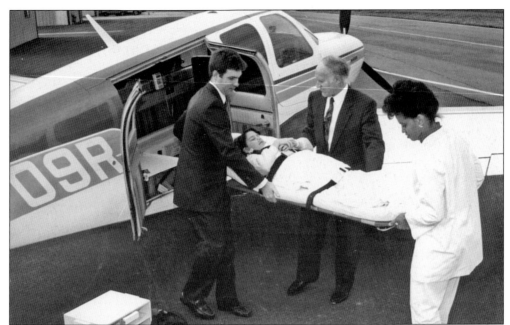

In 1990, a LifePort stretcher system was installed in the Bonanza. This is a self-contained unit with a permanent base secured onto the airplane seat rails. The stretcher base is located on the left side of the airplane behind the pilot's seat and extends to the rear bulkhead. One of the Bonanza's most convenient features is its cargo-type doors located on the copilot's side of the airplane, making it easy to load a patient on the stretcher with both doors open. To show the LifePort's utility, a demonstration was staged at the hangar in Manassas, Virginia, as shown in these photographs. The volunteer nurse assisting in both pictures is Robbie Neely. The patient is unidentified. (MMA.)

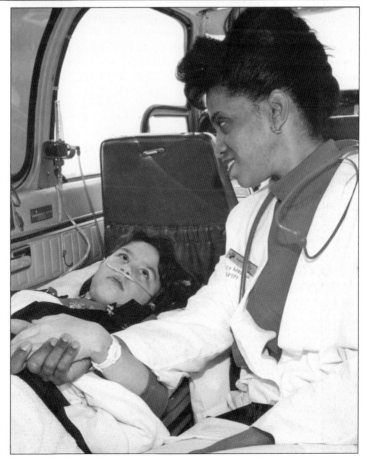

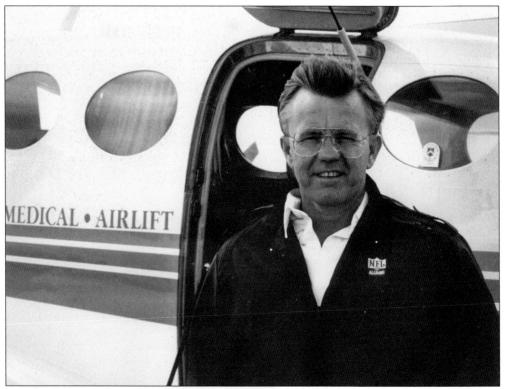

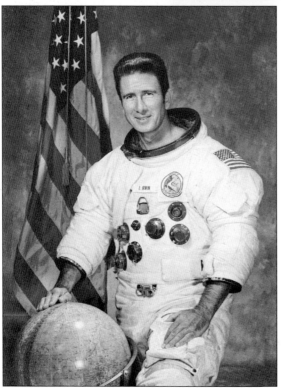

The MMA advisory committee was served by eminent leaders in Congress, the military, the sports world, and other sectors. Sen. Mark Hatfield, U.S. Congressman Frank Wolf, Tom Landry, Rosey Grier, and astronaut Charles Duke were only a few of the individuals who endorsed the aviation charity, represented it within their sphere of influence, and offered advice when asked. "I think it nothing short of a miracle," wrote Wolf in a 1987 letter to MMA, "that you folks have taken on the challenge of helping those in need through a charitable air ambulance operation." Joe Gibbs, head coach of the Washington Redskins, is shown in this 1990 photograph (above) paying a visit to the Manassas hangar. The late Jim Irwin, the Apollo astronaut pictured at left in 1972, was also a friend and advisor of MMA. (Above, MMA; left, NASA.)

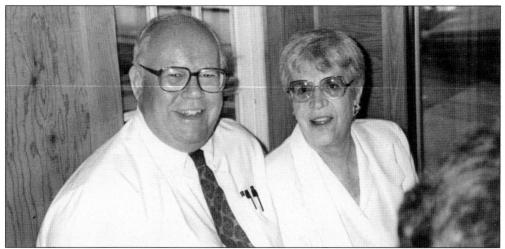

Carol Holt was living in Virginia Beach when Ed Boyer flew down from Washington, D.C., in 1987 to recruit her as a fund-raiser. Formerly the director of development for the Christian Broadcasting Network, Holt agreed to Boyer's proposal that she work as a volunteer. She also agreed to his marriage proposal, and the two were wed in 1988. The couple is above in 1990. Besides raising funds and doing public relations work, Carol, shown below with Ed in this 1999 photograph, also coordinated missions. "We'd get a call. It would take four to six days to coordinate one mission. We had the heart, but we didn't have the cash," she said. Pilots, staff, and others would get busy trying to raise money for the flight. "It was a miraculous beginning. A lot of people said we were crazy." (Above, Carol Boyer; below, MMA.)

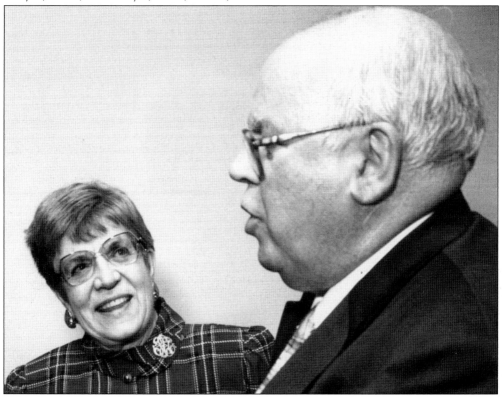

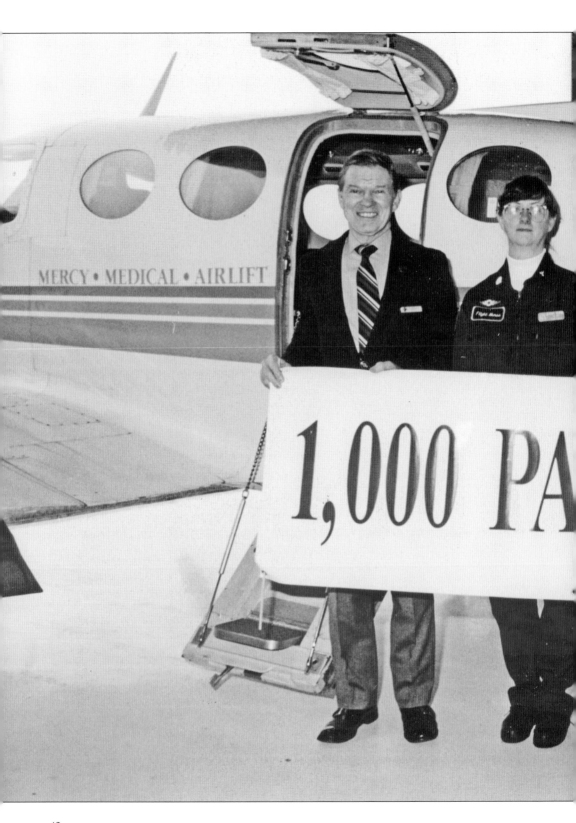

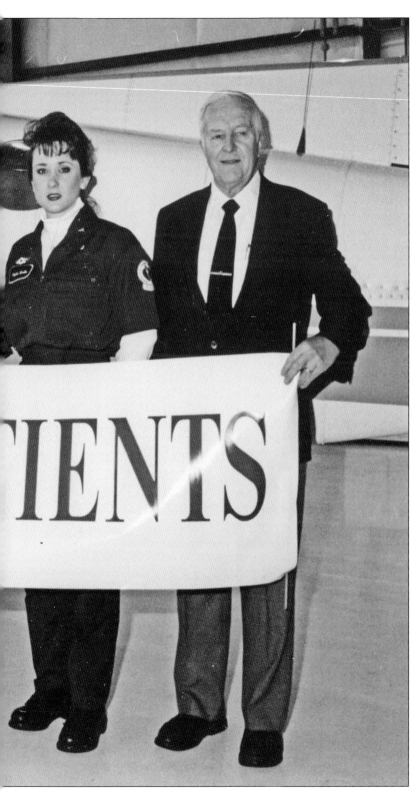

A milestone was reached in 1993 when this picture was taken, marking 1,000 patients transported in the Cessna 421. Pilots Click Smith (left) and Harvey Engen (right) flank the flight nurses. A log of medical missions gives an idea of the variety of patients flown. A 10-year-old child from Richmond, Virginia, traveled to the Mayo Clinic in Rochester, Minnesota, for heart surgery. A 17-year-old with a broken neck flew to Denver, Colorado, from Washington, D.C. A stroke victim traveled from Falls River, Massachusetts, to Atlantic City, New Jersey. The gift of a lift for many meant the gift of life. (Iris Smith.)

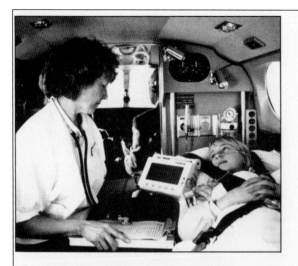

## MERCY MEDICAL AIRLIFT . . .
## The Charitable Air Ambulance
### *Serving Needy DC - VA - MD PATIENTS.*

To help defray the staggering costs of patient transport—MMA's budget for the fiscal year 1987–1988 was nearly $600,000—the charity, eligible as a 501(c)(3), started participating in the Combined Federal Campaign (CFC) in 1987. This annual fund-raising drive is the equivalent of the United Way campaign for government employees, postal workers, and military service members. Its stated mission is "to promote and support philanthropy through a program that is employee focused, cost efficient, and effective in providing all federal employees the opportunity to improve the quality of life for all." This postcard, depicting a typical patient mission and advertising the benefits of the charity, was sent to constituents of the time. (MMA.)

## "Needy DC - VA - MD patients ask for your help."

**It's Combined Federal Campaign and United Way time again,** and needy DC - VA - MD patients need your help more than ever. A year means 365 days of service by the volunteer crews of **Mercy Medical Airlift** providing charitable long-distance air ambulance service for the transport of our children, or elderly and our ill and injured to places of recovery, healing and rest. The media calls MMA the **"High - Tech Good Samaritans."** Hurting families, in times of crisis, call MMA their **"Only Hope."**

### You make it happen!

### Please make MMA your Donor Choice.

Combined Federal Campaign: Write in MMA's # 2193 and the amount of your gift.

| 2193 | $ |
|---|---|
| Agency No. | Annual Amount |

United Way: Write in the amount of your gift and write in Mercy Medical Airlift, P.O. Box 1940, Manassas, VA 22110 in the Designated Gift section on your 1989 Pledge Card.

# *Four*

# REVISITING THE VISION

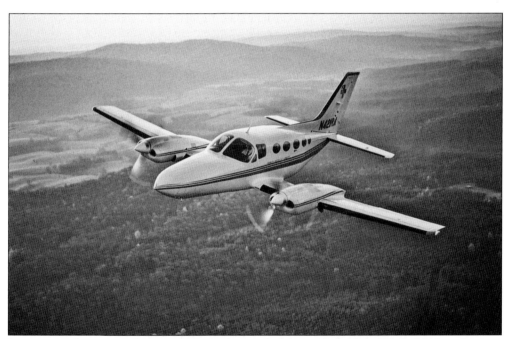

In pursuing the vision of giving wings to the needy, Mercy Medical Airlift (MMA) made plans to expand air ambulance service by establishing bases in Texas and California. But it became apparent that the cost of operating the Cessna at home was itself prohibitive. After prayerful deliberation, the board made the painful decision to sell the airplane, pictured here in 1992, and cease air ambulance operations entirely. (Paul Bowen.)

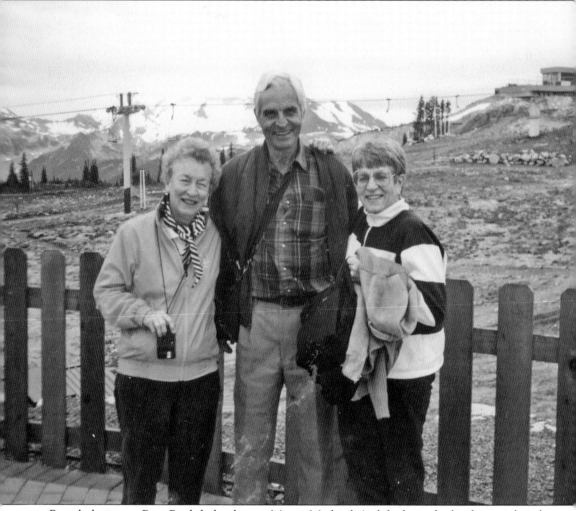

Board chairman Pete Buck helped steer Mercy Medical Airlift through the financial and interpersonal challenges of redefining its mission. He understood that, as a public benefit, the National Patient Travel Helpline was, as he said, "the key to the whole operation" rather than limited, costly air ambulance service. Graduating from Yale University following World War II and earning a doctorate in physics from the University of Virginia, Buck had worked for a navy think tank and the National Academy of Sciences. He and his wife, Alice, a historian with the Atomic Energy Commission (pictured left beside her husband and Carol Boyer), had met the Boyers in 1990 and developed a close friendship. Ed Boyer snapped this picture in October 1996 when the couples were vacationing together in Vancouver. Boyer said, "Pete is a marvelous, creative man of integrity that gave leadership during an important time of MMA's development." (Alice Buck.)

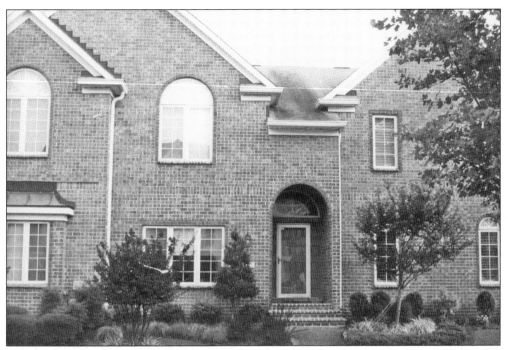

Another seismic change was MMA's decision to move to Virginia Beach. There were major advantages to relocating—it would be cheaper to run operations, and the large pool of retired federal and military personnel in Hampton Roads opened more prospects for building an adequate staff. For an office, Ed and Carol Boyer used an extra bedroom in their home, the condominium on Page Avenue shown in the photograph above. Every other week, MMA's president commuted to the Manassas office, which was still maintained as the administrative headquarters. There the work of paying bills, writing newsletters, taking minutes of board meetings, managing the Combined Federal Campaign, and other public relations activities was accomplished by Barbara Thrasher. She is shown in the bottom picture (left) in 1995 holding a special-needs child flown by MMA. (Above, MMA; below, Barbara Thrasher.)

Before technology streamlined mission coordination, scheduling pilots and patient flights was a telephone and fax affair. Kelp Armstrong, shown in the 1998 photograph at a fly-in with Angel Flight pilot Ralph Burr, was one of the group's first mission coordinators. She worked with Barbara Thrasher in Manassas. Requests came through the National Patient Travel Helpline. Armstrong said she would "plan and organize for 30 missions, but ended up completing only about 10 a month." By the time she left in 1999, Armstrong "was handling 100 a month," demonstrating MMA and Angel Flight's explosive growth. Armstrong also recruited pilots but said that they themselves were the "spark plugs," active in attracting other pilots as volunteers. Ed Boyer said these two women made "valuable contributions to MMA during a challenging transition time and a time of new emphasis on volunteer pilot operations." He credited Armstrong with coining the Angel Flight motto, "the shortest distance between home and hope." (Kelp Armstrong.)

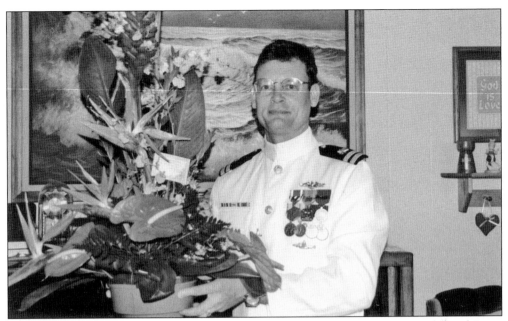

Steve Patterson had just retired from the U.S. Navy as a supply corps lieutenant when Ed Boyer offered him a job as the director of the National Patient Travel Center. That was in 1997, as seen in this picture taken in Hawaii at Patterson's retirement ceremony. Besides his direct involvement with patients and families, Patterson also implemented an e-mail "broadcasting" system enabling Angel Flight pilots to receive patient requests electronically rather than through the cumbersome medium of telephone calls and faxes. Patterson quickly moved into a leadership role as Angel Flight's executive director and Mercy Medical Airlift's executive vice president. He was loved by staff members for being flexible, intelligent, and personable, and for keeping the mission of humanitarian service in the forefront of all activities. (Above, Stephen Patterson; below, AF.)

A program with a major impact is the "Child Lift," initiated by MMA in 1995 to help children participating in a clinical trial at the University of Florida Research Center in Gainesville, Florida. Directed by Dr. Peter W. Stacpoole, shown here in a recent photograph, the study was implemented to treat Congenital Lactic Acidosis (CLA). The condition leads to the abnormal buildup of lactic acid in the blood and spinal fluid. Without specialized treatment, CLA victims usually die as teenagers. The drug dichloroacetate (DCA) helps reduce the acidity and seems to improve neurological function. Forty-four children were initially enrolled in the trial, and MMA provided round-trip flights for most, utilizing charitably donated airline tickets and Angel Flight services, as it still does today. Since that first Child Lift, MMA has been contacted to provide charitable flights related to 120 studies throughout the United States. (UFGCRC.)

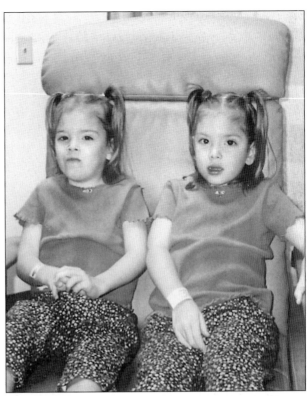

Among the first to participate in the CLA study were Ashley (left) and Amber, twins from Las Vegas, Nevada, shown in the picture above at age seven. Now 15, as seen in this recent photograph below, they began treatment in Florida at age two. The girls are pictured with their older sister, Contessa, and brother, Jesse. Their mother, Gina, explained that, without the drug dichloroacetate and Angel Flight, the twins would not be alive today. Though Ashley can neither walk nor talk, and though both girls use wheelchairs, they attend the ninth grade in a mainstream program and are "very happy," Gina said. (UFGCRC.)

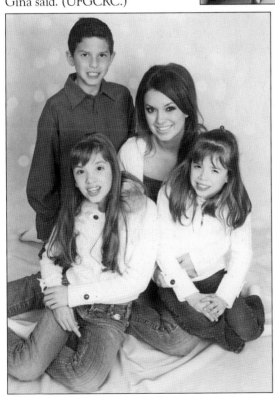

Curtis was born in 1997 and began DCA treatment in 1999, when this photograph was taken. Now 10 and no longer enrolled in the study, he lives with his parents, Sherri and Blake, in Sioux City, Iowa, but Illinois was home when he first started taking Angel Flights to Florida. "He doesn't talk at all, but otherwise he's doing very well," said his mother. (UFGCRC.)

Taylor from Lima, Ohio, was seven when this picture was taken at the clinical research center when he first enrolled in the drug study. His mother, Gina, says DCA has saved his life. Now 16, Taylor continues to take Angel Flights to the clinic. He attends a special school and enjoys music and watching *Wheel of Fortune* with his mom every day. (UFGCRC.)

Working out of a spare bedroom is not the best way to conduct business, so Ed Boyer located an office to rent in Virginia Beach's Haygood area. For more than two years, staff worked in a crowded, 550-square-foot area, running the patient helpline (NPATH), coordinating missions, and managing the Special Lift programs. In this photograph, Allene Cloer and Gene Smelser handle the complicated business of flight coordination. (MMA.)

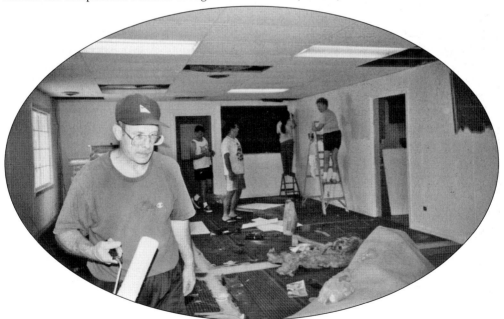

In 1999, renovations began in a larger space in the same office complex with Gene Smelser and other employees doing the work of stripping off wallpaper, cleaning, painting, and installing ceiling tiles, as shown in this photograph. The staff was able to occupy the suite in 2000. (MMA.)

Nonprofit charities with slim budgets depend on volunteers to help shoulder the workload. Westminster Canterbury on the Chesapeake Bay is a luxurious retirement community where residents learned about Angel Flight when the organization first moved to Virginia Beach. Following the presentation, Roy Brun, pictured left in 2005, knew he wanted to get involved and signed up a dozen others to assist with the National Patient Travel Helpline. Volunteers were trained to match requests with transportation resources, and telephones were transferred each morning for a couple of hours from the Haygood office. As a way of saying thank you, MMA began an annual tradition of treating the volunteers to a catered Christmas luncheon in the beautiful Westminster Canterbury penthouse lounge overlooking the bay, as seen in this 2002 photograph below. (MMA.)

"When I come in, I may fold T-shirts, I may stuff 1,500 envelopes, but no job is menial because it all helps the success of Angel Flight." These words, spoken by Marion Myers, pictured in 2002 with her husband, Bob, capture the spirit of volunteerism. Bob, a retired marine officer, and Marion, a retired English teacher for the navy, volunteered for several years. (MMA.)

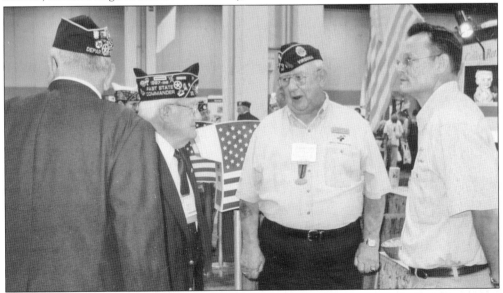

Bob and Marion Myers attended five consecutive conventions of the American Legion representing Mercy Medical Airlift. Bob is himself a member of the Legion and is shown in this 2002 photograph with Angel Flight executive director Steve Patterson explaining the organization's mission to Legionnaires in Charlotte, North Carolina. (Marion Myers.)

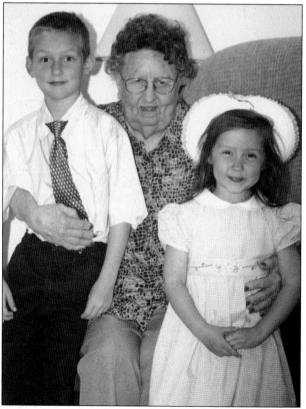

For a child patient traveling in a small aircraft and not feeling well, a warm blanket feels good, especially a blanket sewn by the caring ladies of Project Linus. The Charles County, Maryland, chapter of this national organization has been making blankets for Angel Flight since 2004 (a total of 56), as well as for other children in need, such as flood victims, those in hospitals, and military families. Another "blanketeer" who uses her talents to help others is Myrtle Taylor of La Plata, Maryland. After learning about Angel Flight, the 87-year-old retired professional seamstress began sewing gift packs for child patients. Included in each ziplock bag is a hat, blanket, small pillow, and a stuffed fabric cat, all matched to be gender specific. She is shown with her great-grandchildren, Nicholas (left) and Taylor, in this 2003 photograph. (Above, Mary Hancock; left, Myrtle Taylor.)

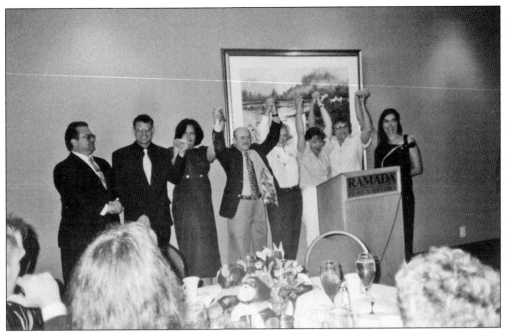

It is important to recognize that "angel flights" were happening all over the country, not just in Mid-Atlantic states. Public-benefit flying developed from the recognition that being a private pilot and owning an airplane could be used for humanitarian purposes, and throughout the country, Angel Flight organizations sprang up in various geographic regions. To bring these groups together cooperatively and to establish uniform protocol for purposes of safety and linking flights, Angel Flight America was created. These photographs were taken in May 2000 at the Ramada Hotel in Virginia Beach. The above picture documents the signing of the protocol agreements. The photograph below shows mission coordinator Allene Cloer in the lobby with the Angel Flight display. (MMA.)

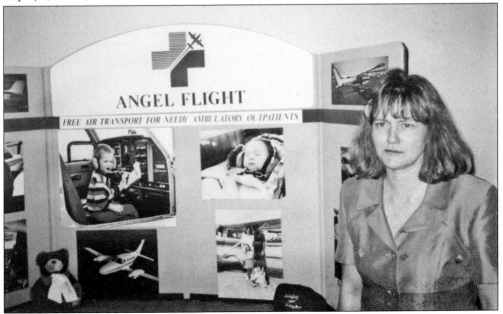

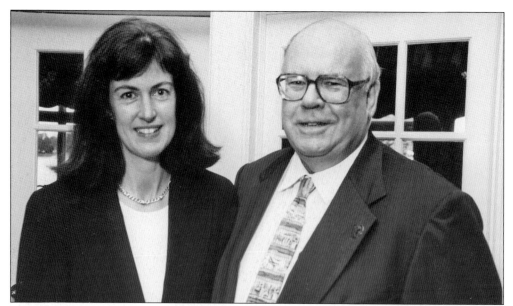

It never hurts to bring in royalty for royal causes, as demonstrated by this fund-raiser for Angel Flight featuring Lady Henrietta Spencer Churchill, the daughter of the Duke of Marlborough. Sponsored in 1999 by a Virginia Beach nonprofit organization, the Circle of Friends, and held at the historic Cavalier hotel in Virginia Beach, the luncheon included a presentation and book signing by the internationally renowned interior decorator and author of *Classic Entertaining*. The event was a sell-out and netted more than $2,500 for Angel Flight. Lady Churchill is shown in the above picture with Ed Boyer. In the picture below, she signs copies of her book for Steve Patterson, Angel Flight's executive director, while volunteer pilot Steve Craven and National Patient Travel Helpline specialist Mary Ann Chisnell wait their turns. (MMA.)

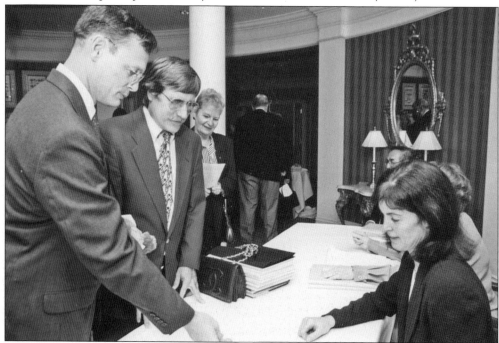

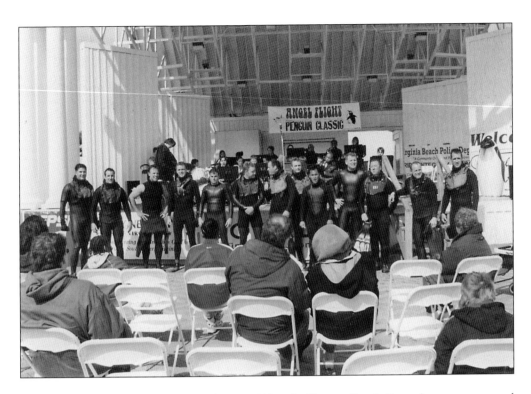

The first Penguin Classic was held in February 1998 at the Virginia Beach Oceanfront as a sponsored walk on the boardwalk to raise funds for Angel Flight. In 2001, U.S. Navy SEALs swam out of the ocean and came on stage, then mingled with the crowd, as seen in this photograph. Other attractions were sand sculpting, as pictured here, ice carving, face painting, a gigantic creation called "The World's Largest Snow Cone," and even a magic show. But beginning in 2003 and continuing annually, the event was changed to become the Angel Flight 5K Walk/Run, with added attractions scaled down to save expenses. (AF.)

Angel Flight employees consider themselves more like a family than a staff and are drawn together by a common cause. The sad stories of patients—children born with deformities, burn victims, teenagers with end-stage cancer—are often shared around the table. But miracles are also described—a pilot who stepped up to take a last-minute mission, resources located to purchase an airline ticket to fly a mother to her comatose child's bedside. Not all the Angel Flight business is serious however. Steve Patterson plays Rudolph during a Christmas party in 2001 and enjoys birthday cake with Theresa (left) and Jerry Dorré (right) as they celebrate Kristin Stiller's (seated) birthday in 2002. (AF.)

*Five*

# WISH UPON A WING

A medical appointment with a top specialist means nothing if the hospital is far away and airline tickets are too costly for the patient. Not only patients but doctors, too, appreciate Angel Flight. Dr. William Gahl of the National Institutes of Health said, "It's a unique opportunity to bring in patients who otherwise would not come to participate in research." Wings are waiting for those in need. (John Billings.)

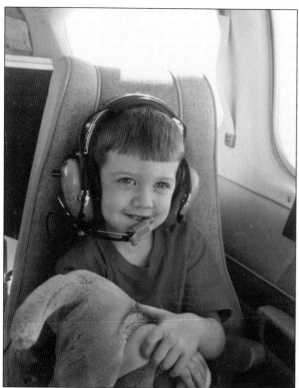

This angel-faced child had three surgeries to repair nerve damage to an arm paralyzed at birth. Pilots flew Benjamin from North Carolina to Texas Children's Hospital in Houston, Texas, in 2003 for the third operation. "Without Angel Flight, we simply could not have made this trip," Benjamin's mother wrote. Every day such letters pour in from families whose urgent requests for help are granted. (AF.)

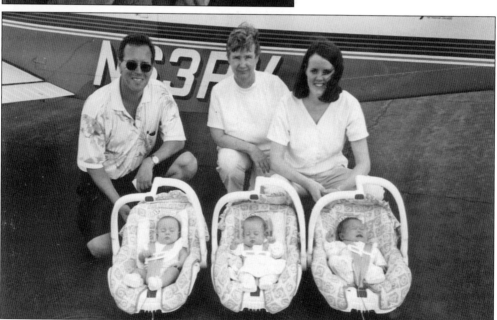

Anna Kate, Brennan, and Rachael are the premature triplets shown in this 2000 photograph with pilot Paul Volk, nurse Joyce Corey (center), and their mother, Cheryl. Under less than ideal weather conditions, Volk flew the babies from Baltimore, Maryland, where they had been hospitalized since birth, to Cheryl's home in Memphis, Tennessee, where she could get support from relatives while her husband completed graduate studies in Baltimore. (AF.)

Angel Flight helps older people too. Edith is a "frequent flyer" who travels to Duke University Medical Center for cancer treatment. After driving the long distance to Duke from her Western North Carolina home, she said she learned about the "Angels" from a local newspaper article. "I've had the most wonderful pilots—such dedicated, beautiful people," she said. The photograph is from 2001. (AF.)

Bill and Edna, seen in this 2004 picture, live in Tangier, Virginia, an island in the Chesapeake Bay accessible only by boat or plane. Bill is a cancer patient, retired waterman, and lay evangelist. He travels regularly to Nassawadox, Virginia, for treatment at Shore Memorial Hospital. Without Angel Flight, he would have to take an exhausting six-hour, round-trip ferry ride. (AF.)

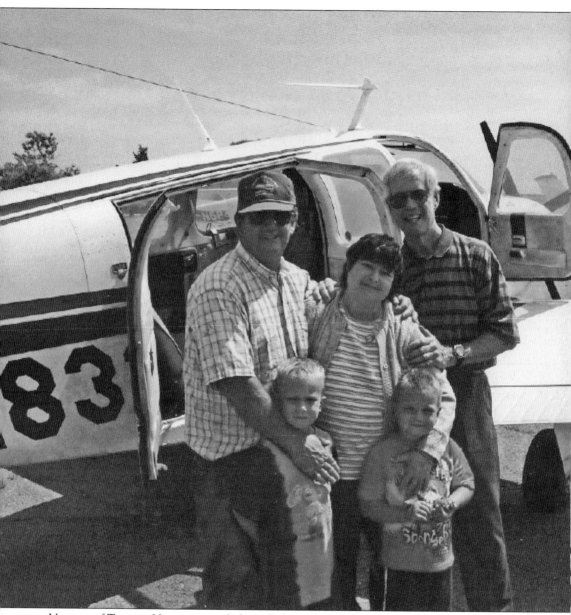

Vanessa of Tangier, Virginia, traveled regularly with Angel Flight from 2004 until her death in January 2006. Like other patients in the remote community, her life depended on the free, time-saving flights that gave her access to medical care. Vanessa's condition required her to take dialysis treatments three times a week on the mainland. Dr. Neil Kaye, an Angel Flight pilot who owns a home on Tangier Island, spoke at her funeral: "I think all of us who flew Vanessa will always remember her positive attitude. Vanessa never complained, and although the pilot could see her pain and impairments, when asked how she was feeling, her answer was always the same: 'I'm doin' purty good.'" This picture shows her returning home from a rehabilitation facility with pilot Richard Love (right) to be greeted by her husband, Larry, and two nephews. (AF.)

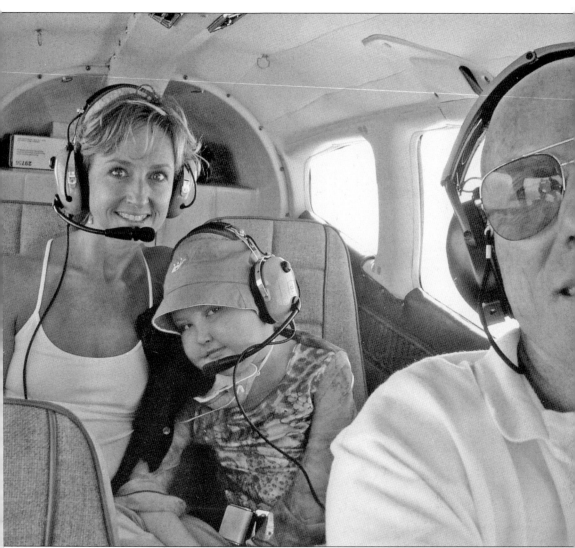

In 1999, at age four, Lacey of Virginia Beach was diagnosed with leukemia. After two and a half years of chemotherapy, Lacey went with her mother, Diane, and younger brother, Tanner, on a Disney cruise. But she began having severe headaches. Once home, a doctor's visit brought dreadful news—leukemia had come back with a vengeance, this time in Lacey's central nervous system. Her only hope was a stem cell transplant. But Diane knew her car, with its troublesome oil leak, would not make it to Duke Medical Center. A local television station contacted her, and Lacey's plight was broadcast on the news. Angel Flight pilot Clint Franklin called the station and said, "Have this family contact me." Lacey got a ride to Duke and underwent a stem cell transplant in June 2002. In the photograph, taken three months later, she is returning home from Durham, North Carolina, with her mother and pilot Hyde Perce. Despite late-term effects, Lacey is a happy middle-school student and "more mature because of what she's been through," said Diane. (AF.)

Stevens Johnson Syndrome is a potentially life-threatening reaction to medication in which patients literally burn from the inside out. After taking the drug allopurinol for six months, Tellis of Salem, Virginia, had an allergic reaction. He was rushed to the emergency room and afterwards airlifted to the University of Virginia burn unit. He lost all the skin on his body. His lungs filled up with blood. "I was on morphine patches left and right," Tellis said. Unable to continue working and now legally blind, he fought for two years to get disability. Angel Flight flew him six times to Miami, Florida, for two eye surgeries and other procedures at Baptist Hospital under the care of leading specialists. "If it wasn't for Angel Flight, there was no way," he said. These 2005 photographs show a nurse (above) offering to pray for Tellis in the hospital, and Tellis with his wife Sharon and two Angel Flight pilots ready to leave Miami to go home. (AF.)

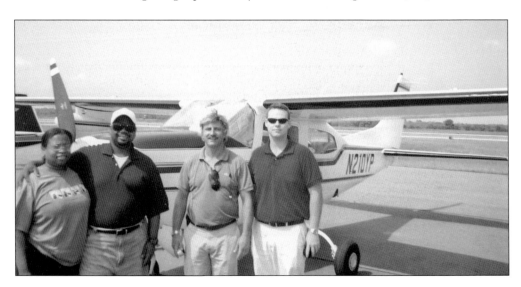

Dominico ("Dommy") of New Bern, North Carolina, was born with severe clubfoot. He was accepted into a program at Shriner's Hospital in Greenville, South Carolina, but driving would have been a hardship for his family. Angel Flight provided transportation for him and his mother to Greenville, where the condition was corrected through surgery. Here he is shown at age two, able to run like any child. (AF.)

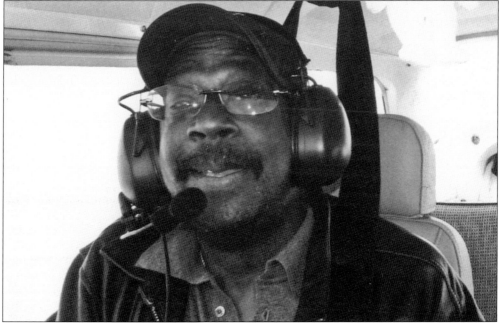

Weather permitting, patients needing transplant surgery can rely on Angel Flight to get them to the hospital within the critical window of time. Steven of Temple, Pennsylvania, flew in July 2005 to the University of Pittsburgh for a liver transplant. He flies once a month to Pittsburgh, Pennsylvania, for follow-up care and currently is on the list for a kidney transplant. (John Billings.)

At her birth, her mother looked at the small face and whispered, "I adore you." That is how Audorria got her name. Barbara, her mom, never dreamed her healthy baby would one day end up in various hospitals and undergo two serious surgeries for a stomach disorder. The 15-year-old high school honor student from Reidsville, North Carolina, shown in this 2005 photograph, was first hospitalized at Brenners Children's Hospital in Wake Forest and remained a patient there for five months. She flew with Angel Flight to a Williamsburg, Virginia, hospital and was again transferred, this time to St. Mary's Hospital in Richmond, Virginia, for an emergency blood transfusion. Barbara got a call to come, but she had only $20 in her pocket. A caseworker connected her with Angel Flight, and she and her other daughter, Alpha, flew to St. Mary's to be with Audorria. Such "compassion (non-patient) flights" are sometimes provided in extreme circumstances, such as Barbara's. (AF.)

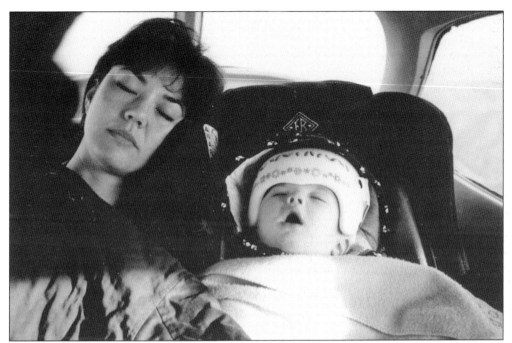

Peaceful skies mean a good nap for this mother and son from Manassas, Virginia. The baby, David, was traveling to Charlotte, North Carolina, for continued treatment of a skull deformity. Cranial Technologies fitted him with a special helmet made of an outer plastic shell with a foam lining that was adjusted regularly. Pilot Brian McAndrew took the picture in 2000. (Brian McAndrew.)

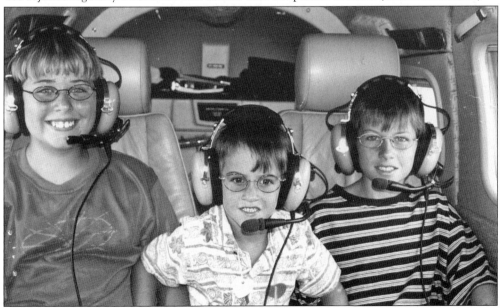

Pictured from left to right, Ryan, Jordan, and Justin suffer from a rare genetic eye disorder, retinitis pigmentosa (RP), that eventually leads to blindness. Every two years they travel to Harvard Medical School in Boston, Massachusetts, to receive experimental treatment from the top RP researcher in the nation, Dr. Elliott Berson. The family relies on Angel Flight for travel, as seen in this April 2004 picture. (AF.)

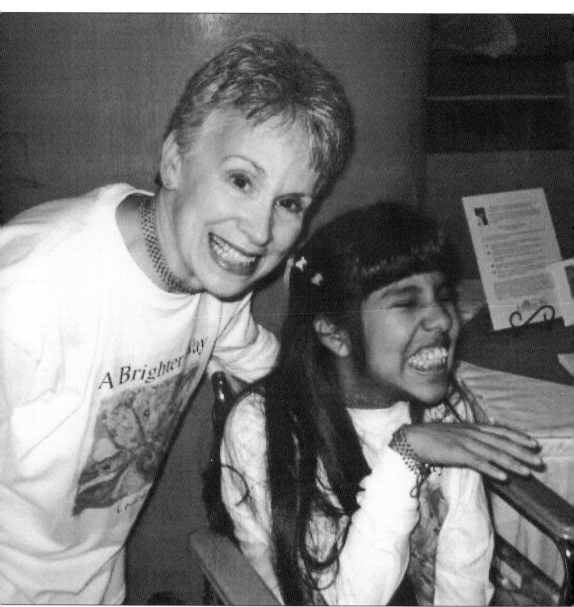

"Her endless smiles from morning to night and her constant 'I love you' is what has kept me alive." These are words spoken by a mother, Leanne, about her daughter, Cristina, pictured in this 2006 photograph. Leanne was severely injured in a car accident in 1988 that ended what she called her "storybook" life as a successful businesswoman and new mom. Four months before the accident, Leanne and her husband had adopted a newborn baby from Lima, Peru. Fortunately Cristina was not in the car. At 15 months, however, she was diagnosed with cerebral palsy. Both mother and daughter have relied on Angel Flight for medical transportation. Over time, Leanne's condition deteriorated, and she was diagnosed with Central Pain Syndrome, requiring travel from their home in Michigan to Brigham and Women's Hospital in Boston, Massachusetts. For pain, Leanne has an intrathecal morphine pump implant normally used for cancer patients. "The pump gave me life," she said. But there are side effects, the worst being a sleep-like state that comes on unexpectedly. (MMA.)

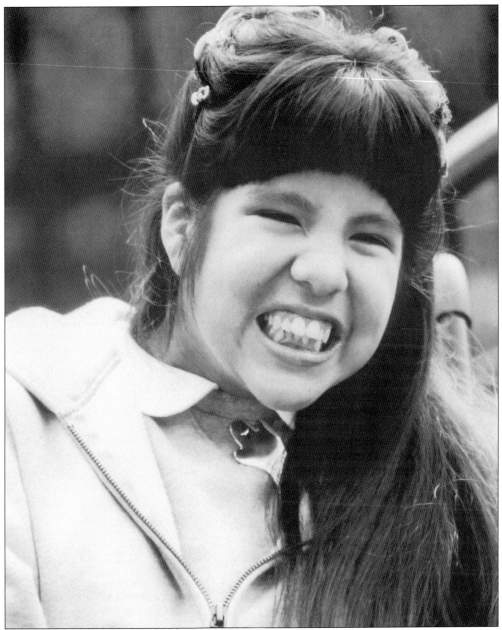

"When I look at my paintings, I can't believe it's my very own artwork! I'm very thankful and proud of what I can do." At age 17, Cristina formed her own business, A Brighter Way, and has exhibited and sold her beautiful watercolors at hospitals and galleries. The director of a holistic health care program purchased Cristina's painting *Sweet Hearts* and said, "It was as though [the painting] leaped forward from the wall with a joy and radiance . . . that were irresistible." Cristina, who is her mother's state-appointed caretaker, also writes poetry and visits retirement homes to share her art and writing with residents. "My paintings seem to bring joy to people who are dealing with cancer," she said. People sometimes treat her like a child because of her small size and disability. But she tells them, "I may talk slower and I may walk slower, but I am really just like you." (A.F.)

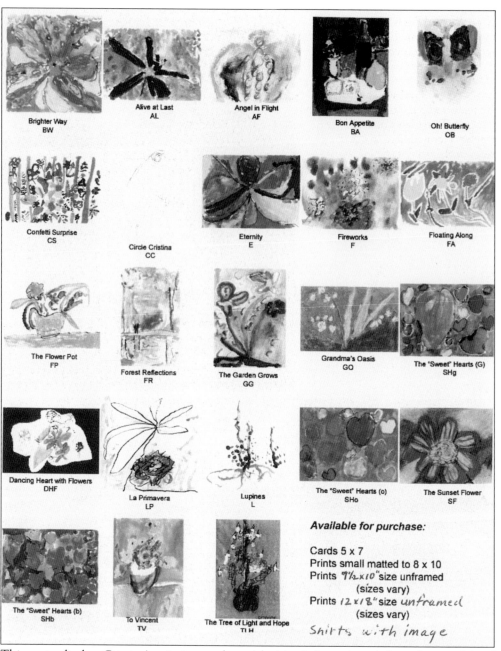

Brighter Way
BW

Alive at Last
AL

Angel in Flight
AF

Bon Appetite
BA

Oh! Butterfly
OB

Confetti Surprise
CS

Circle Cristina
CC

Eternity
E

Fireworks
F

Floating Along
FA

The Flower Pot
FP

Forest Reflections
FR

The Garden Grows
GG

Grandma's Oasis
GO

The "Sweet" Hearts (G)
SHg

Dancing Heart with Flowers
DHF

La Primavera
LP

Lupines
L

The "Sweet" Hearts (o)
SHo

The Sunset Flower
SF

The "Sweet" Hearts (b)
SHb

To Vincent
TV

The Tree of Light and Hope
Tl H

**Available for purchase:**

Cards 5 x 7
Prints small matted to 8 x 10
Prints 9½x10"size unframed
(sizes vary)
Prints 12x18" size unframed
(sizes vary)
Shirts with image

This poster displays Cristina's paintings to date with sizing information. A framed print of *Angel in Flight* hangs in the Angel Flight office as a gift from Cristina to show her appreciation for the numerous free trips provided for herself and her mother. It was also featured on the Angel Flight Christmas card in 2005. The first public showing of Cristina's art was at the Portage, Michigan, Public Library in November 2004. Next she exhibited at Art from the Heart, an Expressive Arts and Comfort Care Program of Borgess Visiting Nurse and Hospice in Kalamazoo. Her bright images, predominantly of flowers, give a glimpse into the extraordinary spirit of this young woman. As Dr. Karen Horneffer-Ginter said after purchasing Sweet Hearts, "I've always appreciated how art can open our hearts and connect us to the richness of our spirits." (AF.)

Not all Angel Flights are strictly medical in nature. Sometimes special circumstances call for compassion flights, as in the case of Sean and Quaneish. These boys, ages five and six, respectively, are ready to board an airplane flown by Tom Gatewood and his copilot. Pictured here in 2000 along with social worker Lori Butler, the children are bound for New York to be united with their adoptive family. (AF.)

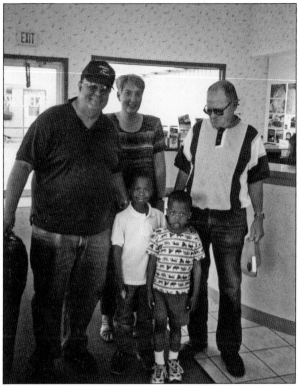

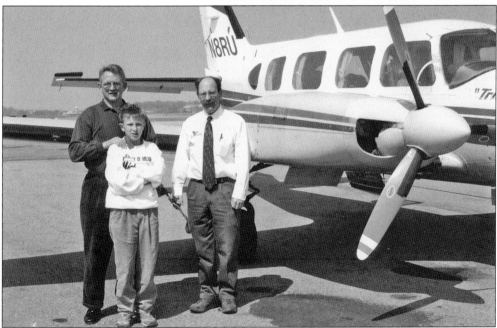

Charles, a father of two boys, took a compassion flight to the Boston Children's Hospital from Chapel Hill, North Carolina, to be with his son, who was undergoing a procedure for a heart condition. Vincent, his younger son, went with him, as seen in this 2003 photograph. Pilot Scott Welch from Pennsylvania flew the second leg of the trip in his spacious Piper Navajo. (AF.)

The considerable range of medical problems experienced by the patients flying with Angel Flight means that, for the majority, evaluation, diagnosis, or treatment is available only at specialty hospitals. Logan, shown in this picture at age three, has been blind from birth and was traveling home to Iowa from Beaumont Hospital in Troy, Michigan, where he was treated by the internationally recognized expert in retinopathy, Dr. Michael Trese. Logan is at least able to detect bright light. Also shown in the May 2002 picture are his mother, Dawn, and linking pilot Dave Shadle from Angel Flight Central. Flights of distances of more than 300 miles are usually handled as linking missions with other Angel Flight regions with a limit of three legs. Sitting on the wing of his Cherokee Arrow is Mid-Atlantic pilot Dick Lawrence, who flew the first leg of the trip. (AF.)

The perky 10-year-old in the right picture is Cheyenne. She has cystinosis, a rare disorder that causes crystals to form in the body's tissues. At age seven, she had to have a kidney transplant. After crystals formed in her eyes, Cheyenne's doctor sent her to the National Institutes of Health (NIH). Angel Flight carried her from her home in Paducah, Kentucky, to Bethesda, Maryland, in 2004, where she received special drops to remove corneal crystals and relieve pain, but the medicine must be administered every waking hour. Angel Flight has a full-time transportation coordinator on site at NIH's Office of Rare Diseases. Marita Eddy (pictured below) was appointed in 2003 and says she is "always amazed at how very sick" patients are and that they are still able to "keep on going and lead rich, full lives." (Right, AF; below, Marita Eddy.)

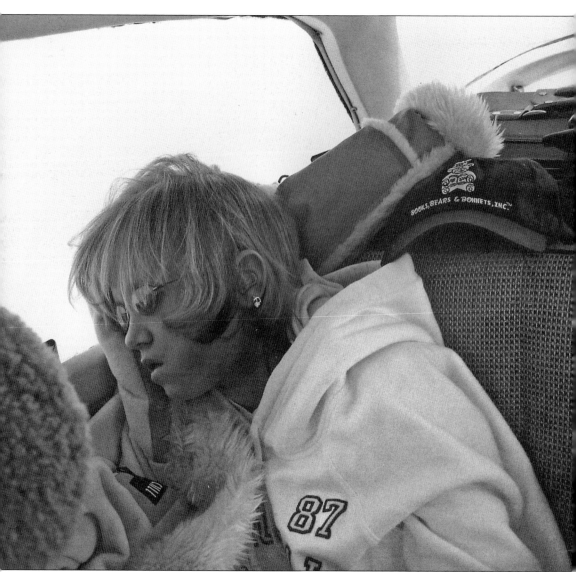

NOMID stands for neonatal-onset multisystem inflammatory disease, a rare condition affecting 400–600 children in the United States. Kayle is one of those youngsters, shown here at age 13 when she was diagnosed. Now 15, the 10th-grader suffers some hearing and vision loss as a result of her condition. She is enrolled in a clinical trial at National Institutes of Health and took two round-trip Angel Flights from her home in Milton, Florida, to Bethesda, Maryland. One of the pilots of the three-legged mission, John Billings, took the picture of the sleeping girl and dryly noted, "She was not a nervous flyer." "All the pilots were just wonderful," said Kayle's mom, Karen. Following the initial diagnostic and screening visits, for which patients must find their own transportation, NIH provides commercial airline tickets. For the initial visit, Angel Flight can fill the need. (John Billings.)

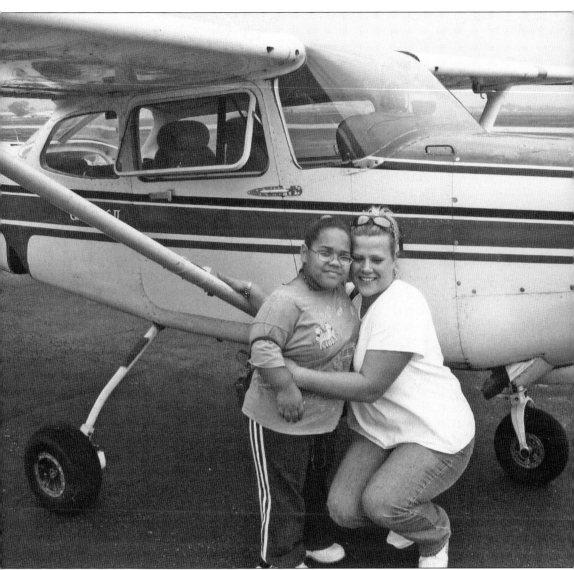

Skeletal dysplasia is the medical name for dwarfism, a condition characterized by the abnormal growth of tissues, organs, or cells. In this 2006 photograph, Miranda gets a big hug from her mother, Josy, upon their safe landing. Angel Flight has flown the 13-year-old girl on numerous occasions to be treated by Dr. William G. Mackenzie. Renowned for his work in skeletal dysplasia, he chairs the department of orthopedics at the Alfred I. duPont Hospital for Children in Wilmington, Delaware. The family learned about Angel Flight through the Shriners Hospital. "We first traveled 16 hours by train. By car, it was 8 hours each way. With Angel Flight, it takes an hour and a half," Josy explained. From their home in Erie, Pennsylvania, Miranda and Josy make the trip to Delaware every three weeks. "Thank God for Angel Flight," she said. (John Billings.)

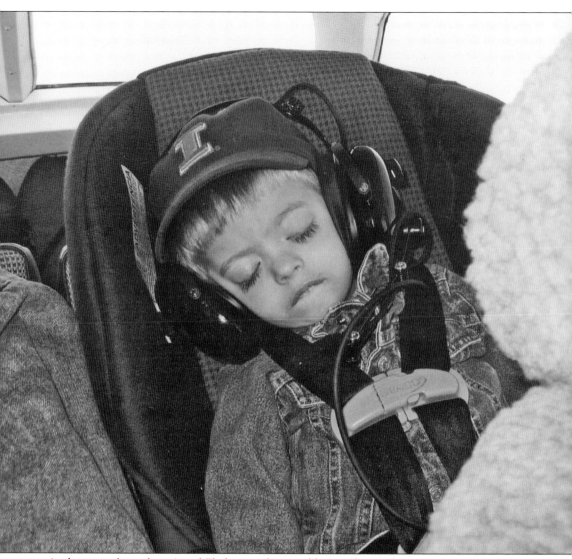

Andrew was four when Angel Flight gave him and his mother, Jody, a ride from their home in Newark, Ohio, to New York City to be treated at Mount Sinai Hospital by an endocrinologist specializing in growth disorders. There Andrew receives a growth hormone that helps muscle tone. Diagnosed at 17 months with a rare condition known as Russell Silver Syndrome, Andrew is small for his age and relies on a feeding tube for nourishment. Though he weighed only 24 pounds when this picture was taken in 2005 by his pilot, John Billings, Andrew enjoys playing the guitar, fishing, and hanging out with his eight-year-old brother, Matthew. "His brother is his world," said Jody. She added that Andrew has deep feelings for other people, which she says is because "he's been through so much." (John Billings.)

Optimism is one of the most powerful weapons in Dori's arsenal as she battles metastatic cancer. Diagnosed in 2003, the 51-year-old single mom from Ohio believes "in having a positive attitude. If you look good, you feel good." Angel Flight took her to NIH for an initial screening to determine her eligibility for a clinical trial. In May 2006, Dori began the trial and continues with outpatient care. (AF.)

Chelsea, shown here at age 10, suffered burns to 60 percent of her body following a house fire in 1995. Over seven and a half years, she received 41 surgeries. Angel Flight provided transportation from her home in Pennsylvania to Shriner's Burn Hospital in Cincinnati, Ohio. Her mother said, "The pilots were very aware of our concerns about flying for the first time in a small plane." (AF.)

By age 10, MarQuetta had undergone five open heart surgeries. Her mother, Astrid, explained, "I lived in the hospital for a month and a half. They wanted me to turn the machine off my daughter. They said she'd be a vegetable." But MarQuetta, born with four heart defects, became an honor student. "Her spirits are so great. My baby is on the ball," Astrid said. "She's always thinking of others." Pictured here in July 2005 at the Norfolk airport, MarQuetta is waiting with mission director MaryJane Sablan for an Angel Flight to take her to Victory Junction Gang Camp in North Carolina. (AF.)

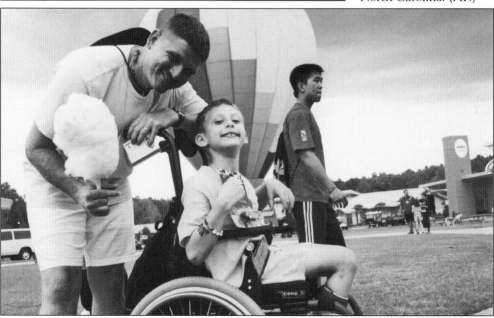

The NASCAR-styled, special-needs camp was established by the Petty family for children with chronic and life-threatening illnesses, and includes a medical center, the Body Shop, and medical staff. In this picture from the summer of 2007, a camper and volunteer have fun during "NASCARnival night," including hot air balloon rides, a real-time NASCAR pit stop, cotton candy, and other activities. (VJGC.)

"Angel Flight smoothed out a huge stretch of the bumpy road we've been traveling." Those are the words of the woman pictured with her husband in this 2006 photograph. Emily and David were on their honeymoon in Colorado when David became dangerously ill and had to be taken to the emergency room—"a gurney instead of a jacuzzi," as Emily put it. He was treated for a 15-month period and underwent surgery in New Hyde Park, New York. Because of his fragile medical condition, David was unable to take a commercial flight. Angel Flight Northeast linked with Angel Flight Mid-Atlantic to get David home to his bride on their farm in Cleveland, Tennessee, where he runs a cattle consulting business. Emily, who holds a degree in communications, does the marketing and helps with chores. The land, shown in the 2005 photograph below, has been in David's family for six generations. (AF.)

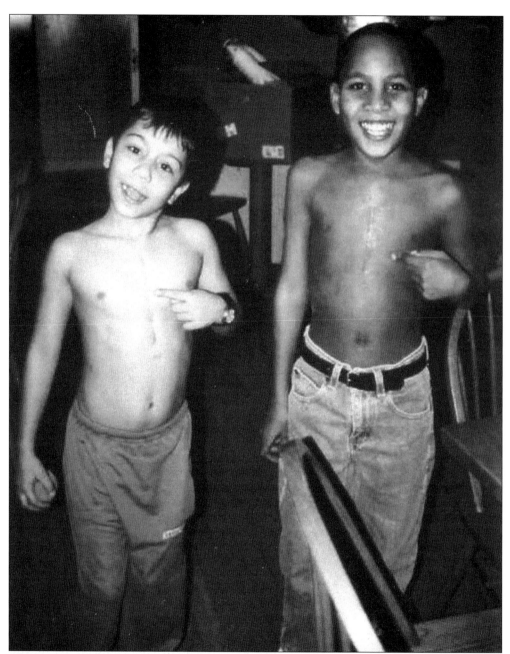

Many hands reached out to save the life of Elyn, a 12-year-old boy from the Dominican Republic. Angel Flight, the Ronald McDonald House, Galilee Church of Virginia Beach, and Rotary International all got involved. Elyn was born with a hole in his heart, a defect that left him so weak he could not run or play or attend school. A medical mission team from Galilee first identified the child in 2004. Angel Flight America provided airline tickets for him and an escort to Albany, New York. There, a leading pediatric surgeon, Dr. Neil Devejian, performed corrective surgery in 2005 with expenses paid by Rotary International's Gift of Life program. In this picture, a vivacious Elyn (right) compares scars with a boy from Iraq who had similar surgery. Though they spoke different languages, the language of friendship is universal. (MMA.)

# *Six*

# ANGELS AMONG US

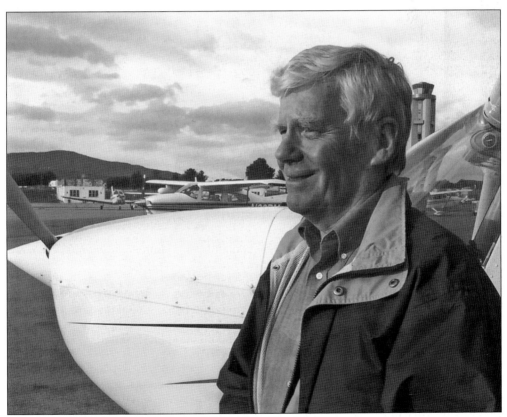

Cleve Benedict has been West Virginia's Pilot of the Year for three consecutive years and was Angel Flight Mid-Atlantic's top pilot in 2005. He signed up with Angel Flight in 1999. To fly missions, the 72-year-old dairy farmer and former U.S. Congressman rents an airplane. Patients have said of him: "He came through for me over and over," and "He'd do anything for me." (AF.)

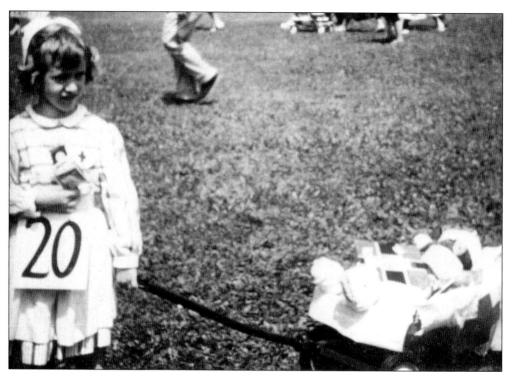

Dr. Mary McCutcheon of Arlington, Virginia, is one of Angel Flight Mid-Atlantic's 40 female pilots. "Everybody you fly has a touching story," says the retired anthropology professor. Her interest in transporting patients dates back to childhood, as seen in this c. 1953 photograph taken at a hometown parade in Lake Forest, Illinois. In her nurse's costume, she pulls her toy "patients" along in a wagon. McCutcheon kept both her curls and her desire to help others, joining Angel Flight in 2001 and using her own airplane, a Cessna Skyhawk. "I was always interested in flying," she said, adding that her grandfather flew with Orville Wright in 1910. McCutcheon described Angel Flight as "a good thing. Patients touch your life like a satellite flying by—you never find out how stories end." (Mary McCutcheon.)

Norfolk, Virginia, business owner Richard Love flew with AirLifeLine before it merged with Angel Flight America in 2003. Like many Angel Flight pilots, Love is a humanitarian on several fronts. In this picture taken in December 1998, Love flew a personal mission of mercy to take eight-week-old "Baby Daniel" Santana with his mother, Miriela, from Cuba to a children's hospital in Hollywood, Florida, for high risk open heart surgery. (Richard Love.)

Richard Love serves on two Angel Flight boards, participates in a bicycle race each year to raise research funds for multiple sclerosis, takes Meals on Wheels to the elderly, and won a Jefferson Award in 2005 for extraordinary public service. He flew numerous patient missions to Tangier Island, Virginia, the setting for this photograph taken with U.S. Congresswoman Thelma Drake during a luncheon to honor pilots in 2005. (Neil Kaye.)

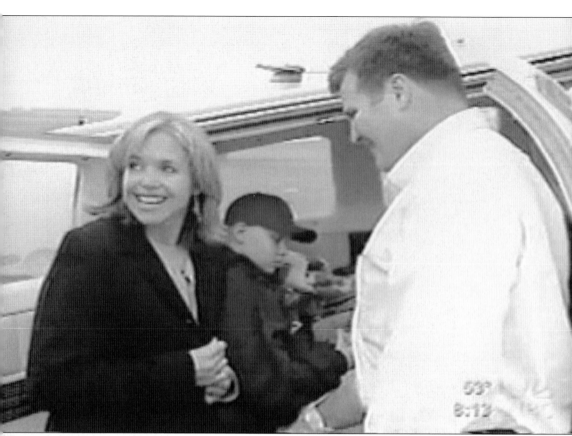

Americans watching the NBC *Today* show on November 20, 2003, saw Katie Couric on the tarmac greeting Richard Love as he landed his Beech Bonanza at Teterboro airport near New York City with a patient from Kentucky. Couric chose to feature Angel Flight as part of a series titled "Who We Admire." Disembarking are Jack and his 14-year-old son, Mitchell, who suffered from an inoperable brain tumor and was seeking treatment at Memorial Sloan-Kettering Cancer Center. Choking back tears, Jack expressed appreciation for the help he had received. "It means everything," he said during the interview that had Couric in tears as well. "We have so much we have to worry about. It's nice when these folks can arrange everything for you. It takes a lot off your mind." Sadly, Mitchell passed away a few weeks later. (NBC.)

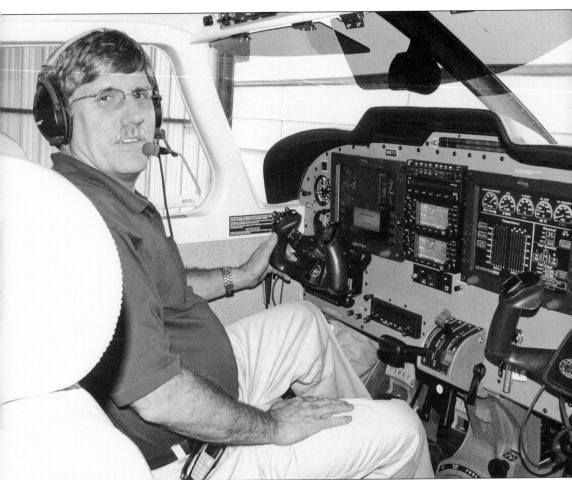

"Angel Flight has changed my life," said Virginia pilot Steve Craven. "There is nothing more gratifying than restoring hope to patients who before had no access to the medical care they needed." Craven is the president of Angel Flight Mid-Atlantic and a founding member of the Air Charity Network (formerly Angel Flight America.) Awarded the prestigious Tire Dealer Humanitarian Medal in 2005, Craven was the owner and president of Craven Tire and Auto, a flourishing business with eight stores in the Washington, D.C., area. He recently sold the business to take a position as the Washington representative of Mercy Medical Airlift. Craven, shown in the cockpit of his Piper Saratoga, joined Angel Flight in 1995. During Hurricane Katrina, he was one of the first pilots to say, "I will go," and accordingly helped evacuate two people, both trapped on the roof of their homes. (David Zielasko.)

Angel Flight pilot Paul Connor is an optician and optical business owner from Ohio whose eyes were opened to the plight of the poor. After listening to a Food for the Poor missionary, Connor was moved to donate funds to build five homes for families in Jamaica. Connor and his wife, Sharon, decided to build, fund, and equip an eye care center in Kingston. In the above picture from November 2006, Connor explains the fine points of opticianry to Winsome, a local student. After building the center at St. Pious X Catholic Church Compound, Connor and his team examined more than 400 patients and fabricated eyeglasses. The work of training local residents to run the center continues, as shown in the picture below. (Paul Connor.)

Frank Gulledge flew 47 Angel Flight missions in 2006, earning him recognition as Angel Flight Mid-Atlantic and Kentucky Pilot of the Year. A former U.S. Marine Corps helicopter pilot and Vietnam veteran, Gulledge received the Distinguished Flying Cross and other honors. After retiring in 1978, the Brandenburg, Kentucky, resident began a career as a flight instructor. Mission director MaryJane Sablan said Gulledge is her "go-to pilot, always there when we need him." (Frank Gulledge.)

Mike Tomlinson of Columbia, Maryland, joined Angel Flight in 2005 following his retirement from the National Weather Service, where he had worked as a manager and chief pilot. He thought Angel Flight would afford him a good way to make a contribution to others while using his flying skills. Here Tomlinson and his daughter Zakiya pose beside a Beaver floatplane while vacationing in Alaska in August 2007. (Mike Tomlinson.)

"A mentor to children and beautifier of Tangier" is how Dr. Neil Kaye was described when presented a Virginia Governor's Volunteer Award in 2007. The psychiatrist and Angel Flight pilot owns a home called Muddy Toes in Tangier, Virginia, besides a residence in Delaware. Kaye and his wife, Susan, also a physician, have given free medical care to their neighbors on the remote Chesapeake Bay island. Kaye enjoys a panoramic view of the First State in this July 2005 picture. He says his chopper is well suited for patient missions, enabling him to travel to places like Smith Island in the Chesapeake Bay that have no airstrip. In the May 2005 photograph below, Vanessa and Larry of Tangier prepare to board Kaye's copter for a trip to the hospital on Maryland's Eastern Shore, where Vanessa received dialysis treatment. Conveniently, the helicopter pad is right behind the doctors' house. (Neil Kaye.)

On May 7, 2005, eighteen planes crossed the Chesapeake Bay to land on Tangier Island, where Dr. Neil Kaye honored Angel Flight pilots by treating them and other dignitaries to a luncheon at Fisherman's Corner. Feasting on hot crab dip and stuffed jumbo shrimp, guests heard Jeff Tarkington, an airport engineer from Talbert and Bright, present plans to repair the island's bumpy runway by leveling and repaving it, as shown in the picture below. Ed Boyer, chief executive officer and president of Mercy Medical Airlift, offered a solution to the problem of continuing patient transport during the construction period. Corporations and news stations with choppers, he suggested, could donate their aircraft for patient missions, gaining them positive publicity as they provided a vital service. (Neil Kaye.)

Besides providing free medical care and Angel Flights to needy Tangier residents, Neil and Susan Kaye have worked to improve conditions on an island called "the soft-shell-crab capital of the world." But with the decline of the crabbing industry, in addition to an aging population and land erosion, islanders and mainlanders alike worry that Tangier is dying. "Of this year's graduating students, none wants to become a waterman; only two are staying on the island," wrote William Lin in a July 21, 2006, article in the *Virginian Pilot*. The Kayes devote time and resources to see that the island survives and thrives and have helped launch several revitalization projects, including a library, a history museum and visitor's center, and walking and water trails. More good news includes a 2007 announcement from Virginia governor Tim Kaine of a grant to help construct a new and desperately needed health center to serve Tangier's 600 residents. (ESVT.)

Jennifer Morgan may be small in stature—5 feet, 1 inch, to be exact—but there is nothing small about her piloting skills. The George Washington University graduate said in her junior year she got "sidetracked by aviation when I decided to get my private pilot license." Morgan earned all her ratings, was a flight instructor, and worked for a commuter fractional-ownership company and a charter operation. Later she "discovered the helicopter world," trained, and went to the Gulf of Mexico to fly crews to and from the oil rigs. In this June 2005 picture, Morgan has landed the Sikorsky S-76 on a Gorilla oil rig for a crew change. The Washington, D.C., resident said she first joined Angel Flight around 1996 and, after a lapse due to several moves, rejoined it in 2006. According to Morgan, the patients she has flown "are incredible, inspirational people who are always a reminder of what is important in life." (Jennifer Morgan.)

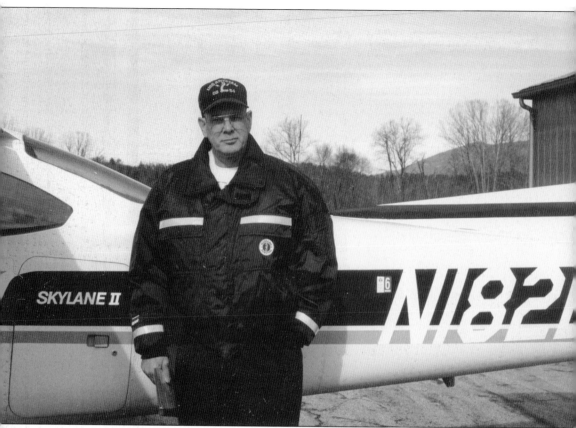

"He'll pick up any mission. 'No' is not part of his vocabulary," said Angel Flight mission director MaryJane Sablan of Frank Ruckman, a pilot and machine shop owner from Morganton, North Carolina. Named Angel Flight Pilot of the Year in 2003 for both North Carolina and the Angel Flight Mid-Atlantic region, Ruckman was "mowing his lawn one evening," said Sablan. "A call came in from the first pilot of a three-legged trip who had to cancel for mechanical reasons. Ruckman replied, 'Yeah, I can do it. Tell them to meet me right now at the airport.' " Three-fourths of the people Ruckman transports are children. "Most of them are kind of sick and tend not to feel too well. I've flown a few to the burn center in Philadelphia. They've been kind of jubilant about flying." Ruckman is shown here in 1999 in Marion, North Carolina, with his single-engine Cessna 182. (AF.)

Angel Flight is fortunate to have Roger and Meyera Oberndorf's support. Meyera has been the mayor of Virginia Beach since 1988 and is a frequent guest at Angel Flight events. The photograph of her and Roger was taken at the Oceanfront Wyndham Hotel, where the Virginia Department of Aviation was holding its annual conference in August 2007 and where Angel Flight won a safety award. Roger has flown for Angel Flight since 2002 and serves as the chairman of the Virginia Aviation Board. Members are appointed by the governor to monitor and publicize the department's activity and to develop safe aviation practices. A retired U.S. Coast Guard Reserve captain and industrial engineer, Roger Oberndorf worked for the Ford Motor Company for 35 years before his retirement. He flies Angel Flight missions in his Cessna 182 when his busy schedule permits. (AF.)

Brett and Caroline Lunger, pictured above in 2006, own a high-performance, six-seat Piper Meridian that can reach an altitude of 30,000 feet. Such planes are desirable for Angel Flight service as they eliminate the need for linking pilots. Retiring from their jobs in 2002, the couple joined Angel Flight the following year. With homes in Delaware and Arizona, the Lungers fly for three Angel Flight regions, including the Mid-Atlantic. The bottom picture shows Linda and her one-year-old son, Jonathan. The pilots flew Linda in May 2004 from Johnstown, Pennsylvania, to Boston, Massachusetts, for cancer treatment. When they picked her up for the return trip two months later, she was "all smiles," as doctors had declared her cancer free. (Caroline Lunger.)

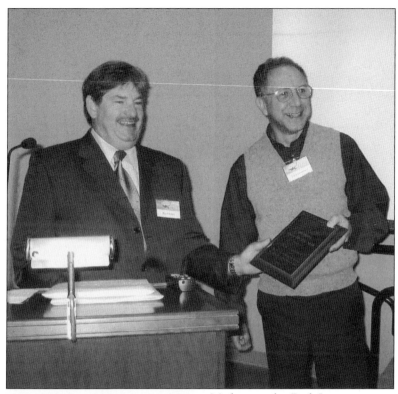

Michigan pilot Dick Lawrence "goes above and beyond being a volunteer pilot," according to MaryJane Sablan, Angel Flight mission director. Lawrence finds airports offering fuel discounts, helps with mission coordination, and is considered a great recruiter of other pilots. He often takes last-minute missions that would otherwise go unfilled. For his service, Lawrence was recognized as Michigan's Angel Flight Pilot of the Year, as shown in this March 2006 photograph taken at a meeting of the Michigan Aeronautics Commission. In the bottom photograph, Lawrence shows off a stack of wood that was cut by hand. "It's good exercise and a challenge landing the wood maul at the right spot," according to Lawrence, not unlike the precision used in flying his Cherokee Arrow. (Dick Lawrence.)

"You might say we pilots have an 'itch,' and Angel Flight provides the 'scratch.' " That's how David Wylie describes the satisfaction he and fellow pilots receive from the charitable service they provide. A resident of Peters Township, Pennsylvania, Wylie was recognized as the top Angel Flight pilot in his state for two consecutive years. He owns a Cessna 182 Skylane, as shown in this recent photograph, an airplane easy for passengers to get in and out of because of the high-wing, two-door design. Another reason Wylie chose the airplane is so his father can ride with him "and look down at the golf courses without a wing in the way." The Wylies own and operate several golf courses in western Pennsylvania. Of his own golf game, Wylie said, "I joke with people that I took up flying because it is the only thing I can control in the air." (David Wylie.)

Angel Flight's senior member is John Billings of Woodstock, Virginia. The 82-year-old pilot has logged more than 27,000 hours in his illustrious flying career, which began in 1937 with flying lessons and included flying B-24s in Italy and a job as a commercial pilot. Billings is shown in the first picture with Joseph, a burn victim from Ohio, during the boy's first time off the ground. Billings is taking him to Victory Junction Gang Camp in Randleman, North Carolina, a camp founded by the Petty family of NASCAR fame for children with serious medical problems. In the second picture, Billings is receiving a coveted Wright Brothers Master Pilot Award in March 2007 from the FAA in Washington, D.C. (John Billings.)

With telephones ringing continually, Angel Flight mission coordination is a highly stressful but rewarding job. "The call volume is very high. We receive about 70 calls each day. On Mondays, 100 or more," said mission director MaryJane Sablan. Pictured from left to right in this September 2007 photograph, Sablan briefs Cathy Wallen and James Jordan on upcoming flights. Patience, diplomacy, chemistry with teammates, attention to detail, creativity, and compassion—these are vital qualities for coordinators as they talk to patients and medical workers, handle paperwork, recruit and register pilots, and work with other Angel Flight regions. "You want to help everyone, but you can't. We have limitations," Sablan explained. Wallen agreed: "My biggest frustration is time. There's not enough to complete tasks." But the emotional reward is great, according to Jordan. "At the end of the day, it's nice knowing you've done something good to help others." (AF.)

Following the terrorist attacks of September 11, 2001, Ed Boyer realized the untapped potential of private pilots in the Angel Flight world to help in case of another national emergency. He applied for and received a grant from the Corporation for National and Community Service to develop a program called HSEATS. This is the acronym for the Homeland Security Emergency Air Transportation System. The national program is designed to speedily mobilize volunteer pilots and airplanes through a communications/command center. Within days after the grant period ended and the system was fully implemented, disaster struck. Hurricane Katrina slammed into the Gulf region in the late summer of 2005, destroying numerous seaside communities and leaving hundreds dead and thousands of homes in ruins. The wreckage of homes can be seen in this photograph taken by Angel Flight Southeast pilot David Knies in Gulfport, Mississippi. (ClassicAirWorks.com.)

Angel Flight pilots plunged into the flood of urgent need caused by Hurricanes Katrina and Rita. They flew relief workers and small priority cargo into affected areas, and evacuated individuals and families out to be relocated and reunited with family members. In this photograph, Jerry Dorré (left) and Angel Flight pilot Ken Hespe (right) prepare to travel to Baton Rouge, Louisiana, from Williamsburg, Virginia, in Hespe's Mooney M20J. Dorré, a retired U.S. Marine Corps major and vice president of operations for Angel Flight, was sent to coordinate relief flight efforts for the Homeland Security Emergency Air Transportation System in and out of Baton Rouge. Armed with survival supplies such as power bars, two changes of clothes, a flashlight, a cell phone, and a Bible, Dorré camped in the Louisiana Air Fixed Base Operator in the Baton Rouge airport, sleeping on a concrete floor and heading up the mission command center. A week later, he was called to Addison, Texas, to coordinate the national response center there. (AF.)

Facing a massive humanitarian crisis, the leadership at Angel Flight headquarters recruited donations of jets and pilots from corporations. In the top photograph, Nancy (front) travels with her mother, Elinor, from Monroe, Louisiana, to Sacramento, California, aboard a Citation jet owned by Qualcomm, a global communications company. Elinor had been trapped in her Jefferson Parish home, became dehydrated, and faced possible renal failure. Following a hospital visit, she received a free flight to join her family in California. Also on board the airplane, as shown in the picture below, was Paul, a 64-year-old man from the Ninth Ward of New Orleans who was pulled from Hurricane Katrina's floodwaters with only the clothes on his back. All totaled, Angel Flight missions exceeded 2,600, making it second only to the U.S. military in missions flown. (AF.)

In this photograph, Marinvia meets her mother, Beverly, on the tarmac of the Newport News/ Williamsburg airport. She and her six children, ranging in age from 3 to 14, had been living in a Baton Rouge, Louisiana, shelter and would now relocate to Hampton Roads, Virginia. Ironically, Beverly was also stranded because after she had left her New Orleans home to visit a brother in Georgia, the hurricane "hit like a bomb," she said, scattering her family everywhere. She decided to join a sister in Hampton, Virginia, and stayed temporarily with her daughter and grandchildren at a motel. Printpak, an international packaging company, donated their business jet to transport Marinvia and her family. The story was featured in the local news. In fact, media coverage for such Hurricane Katrina–related missions was extensive with all major networks featuring Angel Flight's relief efforts. (AF.)

104

Powerful Pennies, Nifty Nickels, Dynamic Dimes, Quick Quarters, Daunting Dollars—at Windsor Woods Elementary School in Virginia Beach, each weekday brought in money for Angel Flight's Hurricane Katrina relief efforts, a total of nearly $2,000. The children raised every cent, raiding piggy banks and doing odd jobs for money. In the above photograph dated September 2005, Mercy Medical Airlift CEO and president Ed Boyer accepts the donation check from a student while principal C. Drummond Ball looks on. The children also made the huge banner, now hanging in the Angel Flight Mid-Atlantic office, and decorated it with airplanes and messages imagined from hurricane victims saying, "I love you," "Help!," "Good going," and "Save my home." A local television station featured these big-hearted kids on the evening news. (AF.)

Because of the timely response to the major hurricanes of 2005, the Homeland Emergency Air Transportation System (HSEATS) was recognized by the Commonwealth of Virginia, receiving the Governor's Community Service and Volunteerism Award. In this picture, the author (second from left) is shown with Angel Flight pilot Richard Love (center) and state government officials at the Library of Virginia in Richmond on October 6. HSEATS also received acclaim when its creator, Ed Boyer, won a distinguished Spirit of Service Award in 2006 from the Corporation for National and Community Service, which granted funds to develop the program. The system works through a high-tech communications center that mobilizes volunteer pilots within minutes after disaster strikes and gives key federal, state, and private disaster relief agencies and organizations direct emergency access to Mercy Medical Airlift Command Control Center personnel. (Wayne Rhodes.)

## Seven

# THE BLUE BEYOND

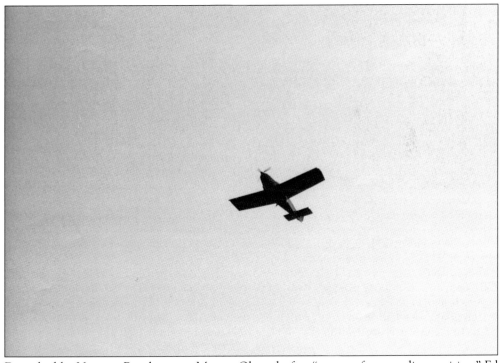

Described by Virginia Beach mayor Meyera Oberndorf as "a man of extraordinary vision," Ed Boyer never stops looking for ways to help patients access medical care. He is constantly widening the net of care by creating new transportation programs and expanding public awareness. This photograph of an airplane was taken by pilot John Billings in June 2006 during an Angel Flight mission. (John Billings.)

With 26 percent of calls coming in to the National Patient Travel Helpline being requests for air ambulance flights, Ed Boyer knew there had to be a way to provide affordable transportation for the critically ill. The solution he devised was Air Compassion America (ACAM), a nonprofit, patient-assistance program of Mercy Medical Airlift. The idea was to hire a mission coordinator to locate and coordinate, at no charge to clients, bed-to-bed ambulance services by comparing bids of private companies and offering families the best price. In 1994, Mercy Medical Airlift was flying four to five air ambulance patients a month. By 2007, ACAM, launched in February 2004, was averaging 22 missions per month and saving patients more than $2.5 million, or an average of 38 percent per mission. Mission coordinators Clara Benjamin (seated) and Robin Reinhart, seen in this September 2007 photograph, offer compassionate counsel for families in distress. (MMA.)

Family members eagerly await the arrival of their father, Dewey, as he is traveling by air ambulance from Miami, Florida, to Norfolk, Virginia, in this July 2005 photograph taken at Landmark Aviation. The trip, arranged by Air Compassion America at a greatly reduced cost, would make it possible for the elderly gentleman to live with his daughter, Diane, and receive home health care. Dewey, who was a preacher during World War II and is Diane's "spiritual mentor and inspiration," as she said, suffered from spinal cord compression and other complications. The aircraft in the photograph below is the Cessna 340 owned by the private air ambulance company making the transport. (MMA)

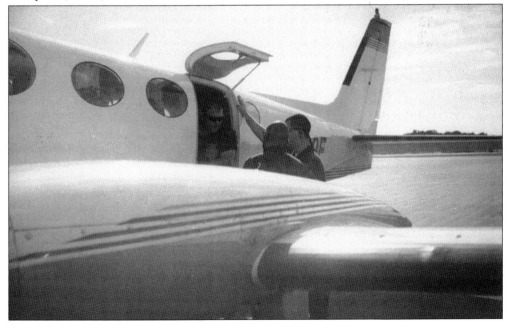

Surviving a crash like that shown in the above picture is unimaginable, but Lauri, her husband, Kem, and their two daughters miraculously came out alive and are recovering. During a vacation trip to Colorado in June 2007, a large four-by-four truck hit their minivan head-on going over a hill at nearly 80 miles per hour. The family sustained serious injuries, including broken bones and bruises, and in Lauri's case, severe head trauma and pelvic damage. Her husband's friend and fellow air traffic controller, Steve, told Kem about Air Compassion America. Mission coordinators arranged an exceptional discount with the air ambulance company that flew Lauri home to Florida. The photograph, taken in July 2007, shows the medical flight crew loading her into the plane. (Suzanne LaCaria.)

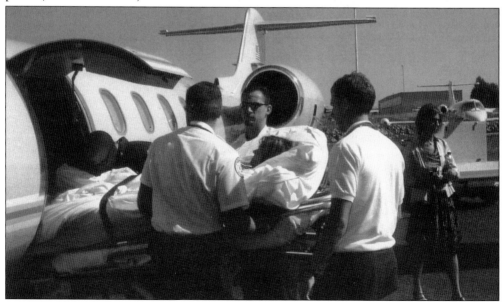

Thomas came into the world against all odds. Weighing only 1.8 pounds, the son of Tricia and Tom was born at 25 weeks with a heart defect requiring surgery. The couple had been in Cape Cod in September 2005 visiting Tom's family when Tricia went into premature labor. She was rushed to Boston's Brigham and Women's Hospital, where Thomas was born. Five days later, he underwent open heart surgery and remained in the neonatal unit for 12 weeks. Tricia remained by his side but yearned to go home to California, where she and the baby could be with Tom and find a nearby hospital. Through a friend, the couple learned about Air Compassion America, which found a flight for half the price that had been quoted to Tom and Tricia. Friends and business associates raised more than enough money for the $16,000 flight, which got mother and child home in time for Christmas. (*Boston Herald* and David Goldman.)

George and Dorothy of Omro, Wisconsin, were visiting friends in Pennsylvania in April 2005 when George passed out. Taken by ambulance to the hospital, he was diagnosed with an aneurysm of the aorta. Fortunately George was able to have surgery immediately and "came through with flying colors," Dorothy said. He remained in intensive care for a month but failed to improve. A case worker contacted Air Compassion America, and mission coordinators arranged a flight for the next day. Later Dorothy wrote to say, "In a case such as ours, being far from home, and the severity of the circumstances, you don't know where to turn. God bless you for being there for us." The photograph was taken in 2005 at a navy reunion. Sadly, George died in December 2006 of other medical problems. (MMA.)

On January 17, 2007, a news conference held at Mercy Medical Airlift headquarters in Virginia Beach informed the public of a new national program to help troops, veterans, and families affected by military deployment in Operations Iraqi Freedom and Enduring Freedom. Air Compassion for Veterans (ACV) was established to provide free medically related air transportation for troops and their families when the federal government cannot assist. "We are committed to the ongoing healing process," said Mercy Medical's chief executive officer and president, Ed Boyer. Nine months after ACV's creation in November 2006, the organization reported 718 missions flown with a public benefit of nearly $400,000. Mayor Meyera Oberndorf attended the conference and said, "This is a brand new chapter in the book of good deeds." The program, funded by the California Community Foundation and a private source, provides air ambulance flights, Angel Flights, and commercial airline tickets based on need. (MMA.)

ACV's first mission was dramatic—an air ambulance flight for two-year-old Alex. While his father, a marine sergeant, was in Iraq, his mother met a man on the Internet and traveled to Texas with him, taking Alex and his baby sister, Ashleigh. When the mom and her boyfriend entered a Lubbock hospital with Alex, who was having trouble breathing, authorities arrested and jailed them for injury to a child. The boy had been badly beaten, with broken arms and ribs, cigarette burns on his back, and other injuries that caused doctors to predict that if he lived, he would be left in a vegetative state. His grandparents, Bill and Sherry, traveled from their Florida home to be with Alex and to pray for him. Afterwards, Bill said his grandson began to improve. When doctors saw increased brain activity on the monitor, he said, "they broke out crying." Alex was flown in November 2006 to Florida for further care, as shown in this picture with a flight medic. Bill reports that the boy is now doing well with ongoing rehabilitation. (Bill Searles.)

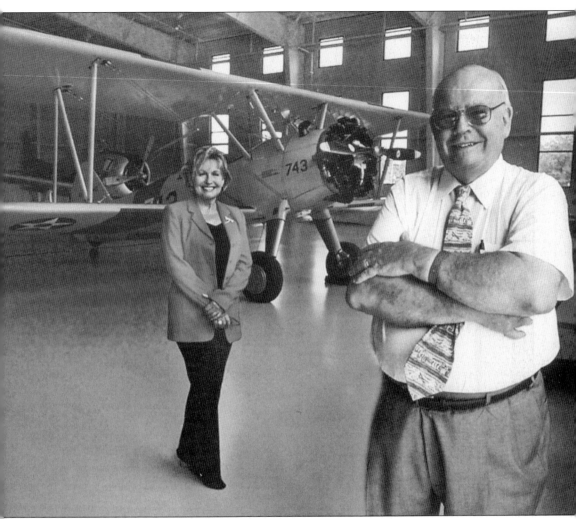

On October 6, 2007, a fund-raiser for ACV called the Halos and Heroes Hangar Celebration was held at a privately owned airport in Pungo, a rural section of Virginia Beach. The World War II–themed event lasted seven hours and honored "Halos," Angel Flight pilots, and "Heroes," wounded veterans flown by the pilots in their airplanes from Walter Reed Army Medical Center. Also included were live music, a barbecue meal, and an air show featuring the Corsair, the P-51 Mustang, and other historic airplanes. The Virginia Beach airport was donated for the event by private pilot and businessman Gerald Yagen and holds one of the nation's largest collections of vintage aircraft. The photograph appeared on the front page of the *Virginian-Pilot Beacon*. Pictured in August 2007 are Ed Boyer, the head of Mercy Medical Airlift, and his assistant, Heidi Greer, who coordinated the event. (*Virginian-Pilot* and David Hollingsworth.)

Those attending the Halos and Heroes Hangar Celebration were treated to a USO show featuring the first live performance of the recording "She's an Army of One," written by Nashville artist Mark Carman. While waiting for a flight in Atlanta in February 2007, Carman noticed that many soldiers in the airport were females. One with graying hair caught his eye. He realized she was most likely someone's mother and wife, inspiring him to write a song. On the airplane, Carman noticed her in a nearby seat, and before the trip ended, he had finished the lyrics to "She's an Army of One." He gave a copy to the soldier whose name, he learned, was Col. Mary Gomez of the U.S. Army Reserve, and dedicated it to all the women serving in the military. (Tra-Star Entertainment.)

As a retired U.S. Navy command master chief and Mercy Medical Airlift's vice president of operations, Jim Smith provides valuable oversight of Air Compassion for Veterans (ACV) and other programs. "Any time we can serve those who serve us, we're doing a good thing," Smith said, adding that ACV operates in cooperation with related programs of the Department of Defense and the Department of Veterans Affairs. (MMA.)

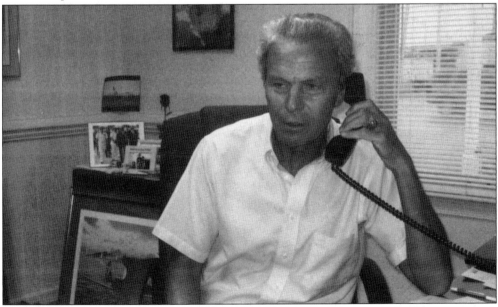

MMA's vice president of program development is Lee Duckworth, a retired navy captain with combat experience in Vietnam and Desert Storm. His military background gives him unique opportunities for developing liaisons between MMA and the military community. He also served as an airline pilot and manager of pilot training for Independence Air. (MMA.)

To recruit Angel Flight pilots and publicize the service, a community representative (CR) program was initiated in 2003. Pilots and other volunteers are trained to talk to civic and aviation groups, schools, and the general public, and are provided with literature and table-top displays. For his energetic pursuit of speaking opportunities, Virginia's John Hoffmann (left) was the Outstanding CR for Angel Flight Mid-Atlantic and the commonwealth in 2006, shown in the above picture at the Virginia Department of Aviation's annual conference in August 2007. Dick Bailey of Bristol, Tennessee, seen in the 2001 photograph below, is a former Angel Flight patient and an evangelist who publicizes the charity every chance he gets, earning him the Volunteer State's Outstanding Community Representative award for 2006. (MMA.)

Making sure the Mid-Atlantic community representatives have needed supplies is Sanovia Baxter's job. In this September 2007 picture, she carries a load of aviator bears to be shipped out for use by representatives exhibiting for Angel Flight. As Mercy Medical Airlift's event planner, Baxter organizes and staffs the annual walk/run and other events that provide opportunities for public outreach. (MMA.)

Katie Smith has worked for Mercy Medical Airlift since 1992, first as a volunteer telephone counselor and later as office manager and receptionist in the Manassas office. To take the job, she resigned in 2000 from Emmanuel Christian School, where she is shown in her cheerful classroom. Smith takes patient calls and speaks to local women's clubs, churches, and service groups on behalf of Angel Flight. (Katie Smith.)

Friends of Angel Flight devise many ingenious ways to raise money for the charity. Princess Anne Women's Club of Virginia Beach held a benefit for Angel Flight entitled Fashions by the Bay in January 2007 at Westminster Canterbury on the Chesapeake Bay. The author was invited to receive the generous contribution of $2,200. She is pictured above (center) with Madeleine Winfree (left) and Gayle Paradiso, officers in the club that organized the luncheon fashion show. In the bottom picture, a golf charity held in Northville, Michigan, also netted $2,200 for Angel Flight, as well as widespread interest in the organization. Toll Brothers, a building company, sponsored the June 2007 event. Bill Bye, vice president of the firm's Michigan division, is the Angel Flight pilot holding the big check. (Above, Irene Bowers; below, Kristen Bye.)

Donations are not always monetary. In 2006, Saab Automobile USA chose Air Charity Network (formerly Angel Flight America) as a partner and gave each region a new 9-7X midsized SUV. Angel Flight Mid-Atlantic celebrated by holding a ribbon-cutting ceremony called Hats Off to Saab at the local Saab dealership in Virginia Beach, as shown in the top picture with Mercy Medical Airlift staff. Party favors were donated by Cloud Nine, an event planner. In September 2007, the newer model, shown in the bottom photograph, was delivered. Saab representative Braden Graham from Detroit, Michigan, hands the keys to Jim Smith, MMA's vice president of operations. The car is used for patient transport and business travel. (MMA.)

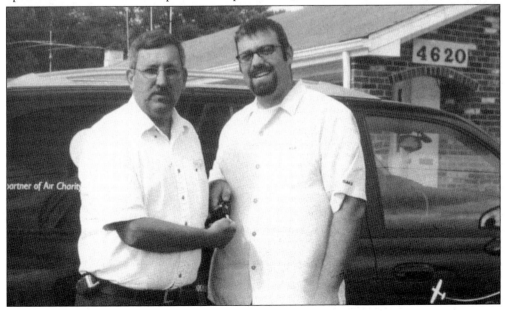

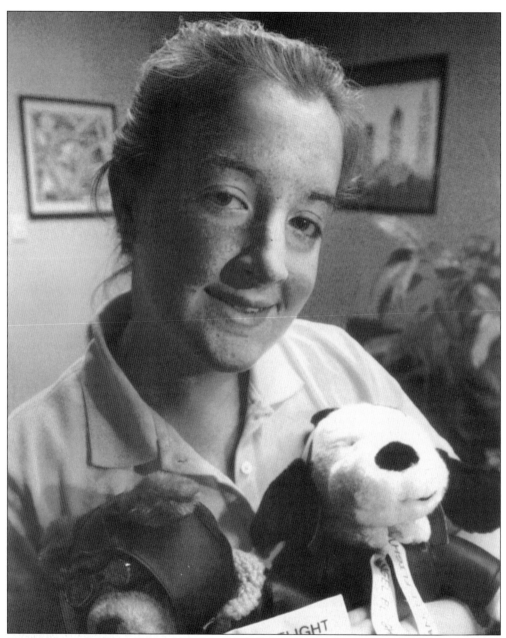

Caitlin Case, daughter of Angel Flight pilot Jeff Case, wanted to recruit pilots for the Angel Flight Mid-Atlantic region and raise awareness of the charity in rural Pennsylvania. For her Girl Scout gold award project, the 16-year-old high school senior staged a "Pilot Olympics" at the Altoona–Blair County Airport. The competition, held in August 2007, involved spot landing and a flour drop. Despite poor weather and limited participation, Caitlin and Jeff passed out literature, interested two pilots in signing up with Angel Flight, and raised $200 in donations. What makes her project so special is the fact that Caitlin is a patient herself and suffers from a rare disease. Besides having had 60 surgeries already, Caitlin has to travel to Philadelphia every three months to remove tumors from her vocal chords. In the picture she poses with Angel Flight's mascots, an aviator bear and dog. (*Patriot-News* and Michael Fernandez.)

On a weekend in early September each year, the skies over Virginia Beach thunder with the Blue Angels, dazzling audiences with feats of skill and technology. But there are other angels at the Naval Air Station Oceana air show too—Angel Flight pilots and staff members who share the good news about free medical flights, with people stopping by the booth or checking out the small airplanes exhibited on the flight line. Dan Sweeny is the volunteer pilot pictured with his wife, Janel, and his Piper Archer at the 2007 air show. In the lower photograph, Elaine Green, a Mercy Medical Airlift employee, talks with an interested passerby. Some 220,000 people attended the 2007 show. (AF.)

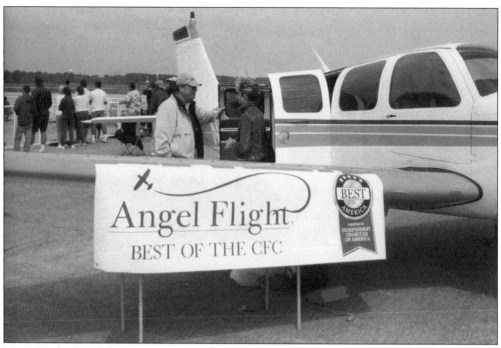

Mercy Medical Airlift and its programs participate in the Combined Federal Campaign, an annual fund-raising drive drawing support from federal employees, postal workers, and members of the military. This picture of the Bonanza was taken in April 2007 at the Langley Air Force Base show, Air Power over Hampton Roads. Rodney Davis, a volunteer pilot and community representative from Virginia Beach, explains Angel Flight's benefits. (Jeff Douglass.)

"Success," said Harvey Firestone, founder of the famous tire company, "is the sum of details." In managing organizational involvement in the CFC, Lissette Melendez makes sure the details of deadlines, applications, and events add up on time and in order. The fact that, for every dollar donated, 97¢ goes directly to programs is a good selling point for CFC shoppers. (Lissette Melendez.)

She jokingly calls herself "Fuzzy Math Specialist," but there is no doubt in the minds of colleagues counting on paychecks or the auditor making her yearly visit that Dale Johnson knows her debits from her credits. Mercy Medical Airlift's scrupulous finance manager oversees the numbers for an organization that has earned the highest four-star rating from the watchdog group Charity Navigator for five consecutive years. (MMA.)

At Mercy Medical Airlift, phone lines are lifelines connecting desperate callers with resources. The point of entry for most patients, families, and medical case workers is the National Patient Travel Helpline, where calls are answered by Shara Gray (rear center). Gene Smelser (left) handles Special Lift and donated airline ticket programs, assisted by Elaine Green (right). Linda Ford is the front desk receptionist. (MMA.)

# RESOURCES

Angel Flight is one of many programs managed by Mercy Medical Airlift. The list below gives contact information and a brief description of each nonprofit 501(c)(3) charity.

National Patient Travel Helpline (NPATH)
1-800-296-1217
www.PatientTravel.org
A single source of referral information on the full spectrum of charitable long-distance air medical transportation options.

Air Charity Network
1-877-621-7177
www.AirCharityNetwork.org
A national charitable aviation network of 10 independent member organizations that match people in need with free flights and other travel resources.

Mercy Medical Airlift
1-757-318-9174
www.mercymedical.org
Association manager of the many programs run from the Virginia Beach office. Also operates several charitable and discount commercial airline programs for patients needing financial assistance for medically related travel when the travel distance exceeds 1,000 miles. Manages Special Lift programs for children and adults enrolled in clinical trials where treatment requires travel to distant clinical research centers.

Angel Flight Mid-Atlantic
1-800-296-3797
www.AngelFlightMidAtlantic.org
A member of the Air Charity Network, AFMA covers an eight-state region, including Virginia, Maryland, West Virginia, Kentucky, Ohio, Pennsylvania, Delaware, Michigan, and the District of Columbia. Volunteer pilots—some 1,500 in all—fly patients to specialized medical care for distances of less than 1,000 miles.

Airlift Hope of North Carolina and Tennessee
1-800-325-8908
Volunteer pilots provide charitable medical air transportation for patients departing from North Carolina and Tennessee.

Air Compassion America
1-866-270-9198
www.AirCompassionAmerica.org
The free service helps patients and families undergoing a difficult health crisis by offering compassionate counseling and working to lower air ambulance and medically related travel costs.

Air Compassion for Veterans
1-888-662-6794
www.AirCompassionForVeterans.org
The group provides medically related air transport services to troops, veterans, and their families affected by military deployment in Operations Iraqi Freedom and Enduring Freedom. The service also assists with transportation when the federal government cannot do so.

Victory Junction Gang Camp
1-877-854-8867
www.victoryjunction.org
Victory Junction Gang Camp in North Carolina was founded by Kyle and Pattie Petty in honor of their son, Adam. The year-round special needs camp serves children with medical problems from ages 7 to 15. The camp is free and relies on donations.

A Brighter Way
P.O. Box 604
Portage, MI 49002
248-227-1831
Contact A Brighter Way for a color poster display of Cristina Powell's beautiful paintings as well as ordering information.

Anyone who would like to donate to any of these programs can do so by visiting www.mercymedical.org or by sending a contribution by mail to:
Mercy Medical Airlift
4620 Haygood Road, Suite 1
Virginia Beach, VA 23455.

When not working at Angel Flight, where she has been director of public affairs since 2003, or teaching as an adjunct professor at Old Dominion University, Suzanne Rhodes seizes opportunities to absorb the sights and sounds of the ocean with her husband, Wayne, at a remote section of Virginia Beach she named Holman Beach after photographer Robert Holman, who took the picture in April 2007. A graduate with a master's degree in poetry from Johns Hopkins University and a bachelor's degree from James Madison University, Rhodes has published (under the name Suzanne Clark) two volumes of poetry, a book of literary sketches, and a textbook for student poets. She has published essays and articles in various magazines and worked as a newspaper columnist for the *Kingsport Times-News*. Wayne is a builder and developer, a commercial pilot, and a volunteer who has devoted many hours to Angel Flight. Together they have five children and three grandchildren. (Robert Holman.)

# ACROSS AMERICA, PEOPLE ARE DISCOVERING SOMETHING WONDERFUL. THEIR HERITAGE.

Arcadia Publishing is the leading local history publisher in the United States. With more than 4,000 titles in print and hundreds of new titles released every year, Arcadia has extensive specialized experience chronicling the history of communities and celebrating America's hidden stories, bringing to life the people, places, and events from the past. To discover the history of other communities across the nation, please visit:

# www.arcadiapublishing.com

Customized search tools allow you to find regional history books about the town where you grew up, the cities where your friends and family live, the town where your parents met, or even that retirement spot you've been dreaming about.